unfurling
a mixed-media workshop with
Misty Mawn

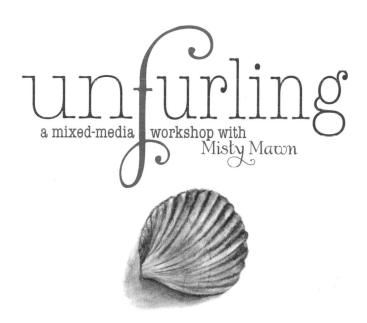

QUARRY

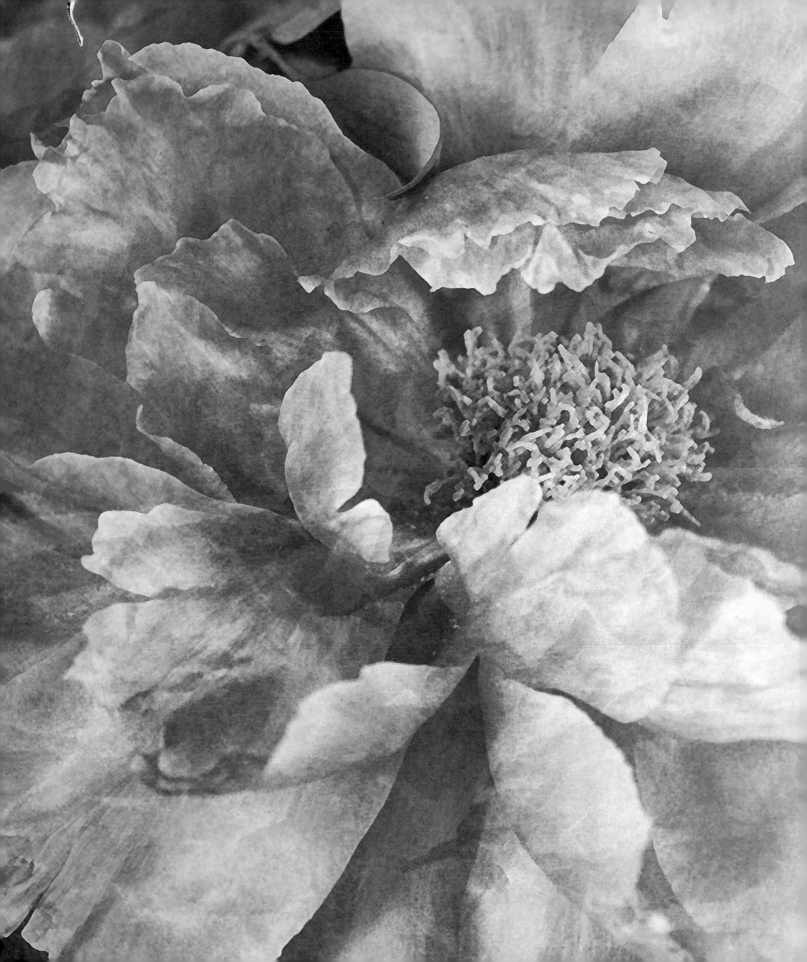

unfurling

a mixed-media workshop with
Misty Mawn

*inspiration and techniques
for self-expression through art*

BEVERLY MASSACHUSETTS

QUARRY BOOKS

First published in the United States of America by
Quarry Books, a member of
Quayside Publishing Group
100 Cummings Center
Suite 406-L
Beverly, Massachusetts 01915-6101
Telephone: (978) 282-9590
Fax: (978) 283-2742
www.quarrybooks.com
Visit www.Craftside.Typepad.com for a behind-the-scenes peek at our crafty world!

Library of Congress Cataloging-in-Publication Data is available

ISBN-13: 978-1-59253-688-7
ISBN-10: 1-59253-688-3
Digital edition published 2011
e-ISBN: 978-1-61058-022-9

10 9 8 7 6 5 4 3 2 1

Design and Layout: Sandra Salamony

Printed in China

unfurl | ən'fərl |

VERB: to make or become spread out from a rolled or folded state, especially to be open to the wind

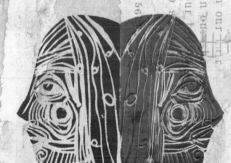

"And the day came when the risk to remain tight in a bud was more painful than the risk it took to blossom."

—Anaïs Nin

Contents

Introduction

While writing this book, I felt myself tuning in to my own art to better understand why and how I use it to communicate inwardly, with those I know and with those I will never know. Art has a way of tricking us into expressing ourselves without even knowing it. We pick up a brush, add a little paint, start moving it around, step back, and suddenly our emotions appear on the canvas, naked.

"Ten thousand hours makes the master."

—Unknown

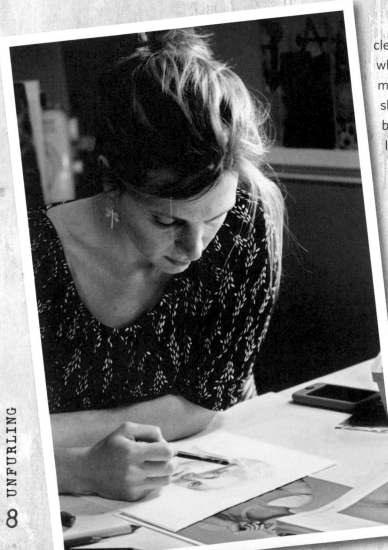

The ability to create art like this is truly a gift, a way to cleanse your thoughts, heal your spirit, and make space for whatever comes next. For as long as I can remember, my mom has had her own cleansing ritual: walking. Every day, she walks to clear her mind, ease her soul, and keep her body healthy. I have always admired her consistency, and I now realize that I have my own soul-cleansing method. As much as I love to walk for miles outside to release the day's worries, art is my way. During the past thirty-some years, I have grown from an inept, immature artist to a more experienced, genuine one who, although still very much finding her way, now realizes the importance of practice, incorporating art daily into her life (even if the practice is awful at first), and making mistakes along the way. From these mistakes, I most often learn something valuable.

I have taken my fair share of basic art classes. I've learned how to hold a pencil, draw the human figure, mix paint, sculpt with clay, make a teapot, and

mix mediums. I survived the monotonous art history classes that filled pages of my notebooks with doodles. I have taken workshops and photography courses, and I've learned by trial and error. I understand the need for these prerequisites to help a burgeoning artist, and throughout this book, certain sections offer similar, more traditional teaching methodologies. But if you come away from this book with anything at all, it should be that you must get into your studio or art space and make art.

It doesn't matter if your art space is a tiny spot on the floor or a converted potting shed. It can be traditional or not. Thousands, if not millions of artists out there never took a single art lesson, but they create amazing work. There also are pros who can't seem to get noticed at all. Making art is not about what you know as much as about putting in the time, picking up the brush, dipping it in your favorite paint, and creating from the heart. If you have never painted before, there's no time like right now to get out your supplies, whether a pencil and paper or a studio's worth of dream tools.

I hope this book helps you, and anyone who picks it up, in a way that allows you to grow as an artist, to blossom from within. Plant the seed, nourish it, and watch it unfurl.

"Whatever you are, be a good one."

—Abraham Lincoln

art |ärt|

NOUN: the expression or application of human creative skill and imagination, typically in a visual form, such as painting or sculpture, producing works to be appreciated primarily for their beauty or emotional power

Art is an exciting and fulfilling way to express and stretch, to look within and learn what we did not know existed. With determination and practice, every person who dreams of becoming an artist can. The next few chapters—and the entire book, really—offer several techniques and many exercises to inspire, encourage, and expand every inner artist.

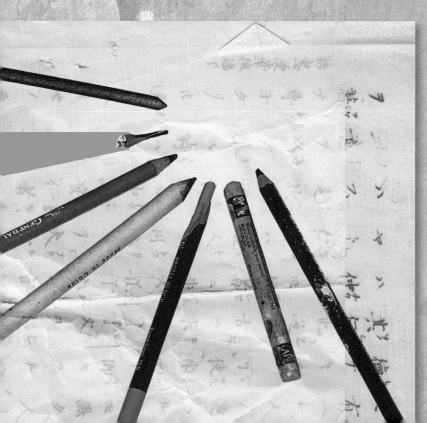

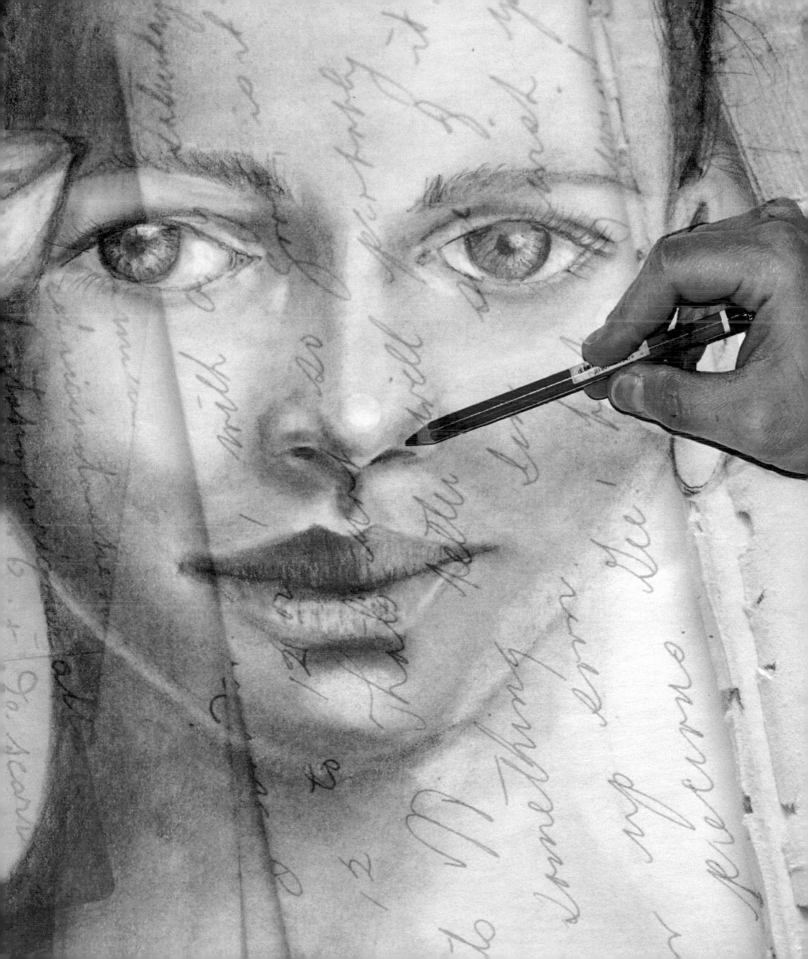

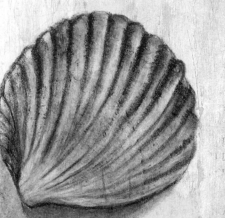

Drawing

There are many ways to create a drawing, and myriad different materials available. This fact can sometimes overwhelm an artist, especially one just starting off, but realize it's possible to keep it simple: All an artist really needs is something to draw *with* and something to draw *on*. These can be as unsophisticated as a rock and a piece of slate. Of course, if the opportunity presents itself, explore many options to find the best and most appropriate material for the drawings you wish to create.

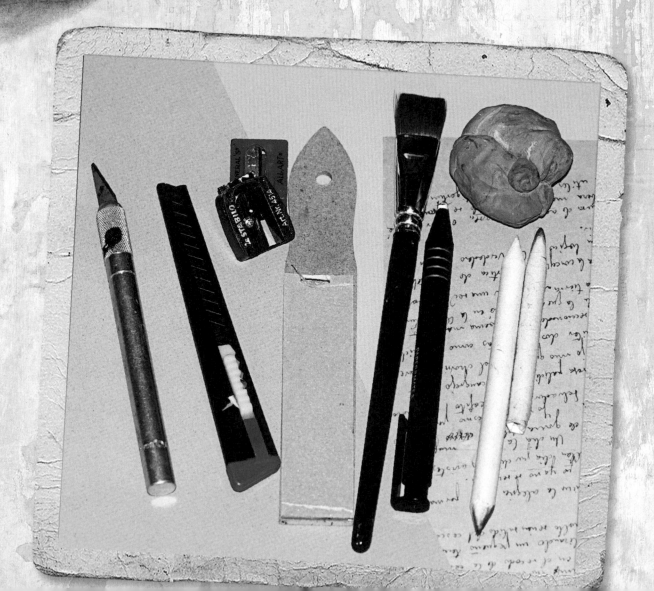

delightful as drawing."
—*Vincent Van Gogh*

As a young artist, my supplies were limited: paper, #2 pencils, magazines for collage, glue, markers, crayons, a journal. At the time, those were sufficient. But as I developed my artistic skills, I slowly built up my supply collection. Today, my supplies resemble those I owned back then, just slightly fancier versions. Could I still make the same art with less? Yes! Making art isn't about which supplies you use; it's about what you need to express yourself as an artist, as a person.

Materials

Most art supply stores sell these materials. Check the "Studio Supplies" section of the Resources chapter on page 118 for details.

Graphite Pencils

The most common pencils are HB, or #2 pencils. (The *H* stands for "hardness," the *B* for "blackness.") They are made from graphite (a gray, crystalline, allotropic form of carbon that occurs as a mineral in some rocks) and a clay binder. They range from very soft (9B) to very hard (9H). Typically, the softest I use is a 4B and the hardest is rarely anything harder than an HB. Hard pencil works well for making thin, crisp lines such as those in architectural drawings. Soft pencils, which move around the paper and erase easily, work well for simple drawing and sketching.

Charcoal Pencils

These pencils, which offer very black marks that blend and smear easily, are made from compressed charcoal ranging from soft to hard. They work great for creating dramatic portraits, sketches, landscapes, or anything that would benefit from intensity with dark lines.

pencil drawing

charcoal drawing of charcoal pencils

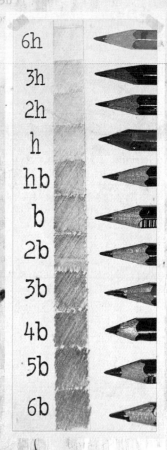

6h
3h
2h
h
hb
b
2b
3b
4b
5b
6b

pencils and their hardness

drawing done with vine charcoal

vine sticks

blending sticks

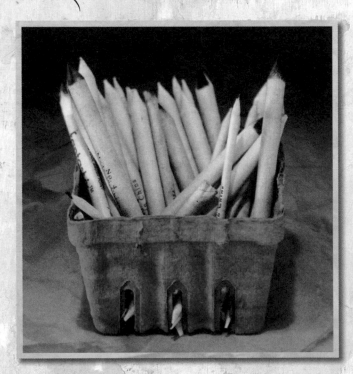

Vine Charcoal Sticks

Burning certain types of wood, such as willow vine, creates soft charcoal sticks. These little sticks work wonderfully to sketch quickly and erase easily because they move effortlessly on the paper, and their marks wipe off with a cloth, allowing the artist to start from scratch when necessary.

Tortillions or Blending Stumps

These tools come from fibrous or tightly wound paper and work best when used at an angle to blend and soften marks on a drawing. As tempting as it sounds, try not to use your fingers to blend pencil marks; they deposit oil and can stain your drawing.

Kneaded Eraser

This gum-like eraser is great for lifting off all kinds of marks, and kneading it keeps your hands clean at the same time. A good eraser is an indispensable drawing tool, not only for making corrections, but also for adding contrast where needed.

Stick Eraser

A plastic retractable tube houses this long, vinyl eraser, which can sharpen to a point to reach the small, detailed areas of a drawing.

Water-Soluble Pencil

The STABILO Marks All water-soluble pencil is one of my absolute favorites. I generally buy at least a dozen at a time. It has a soft, waxy lead that works on any surface and with almost every medium.

Artist Crayons

Several companies make water-soluble crayons, and each works in its own way, but some are more vibrant than others. (Check the "Studio Supplies" section of the Resources chapter on page 118 for more information.) These tools are fun to draw with because they're lively, waxy, smooth, easy to take on the go, and forgiving. They're more fun than any crayon I had as a child. Plus, because they're nontoxic, they're safe to use for painting on skin (just dip them in water first). Use them alone or combine them with other mediums.

Colored Pencils

I personally have never had the patience required to be a colored-pencil artist, with the many layers it takes to create depth and outstanding color. That said, I still like to draw with colored pencils. They have a waxy core and are tinted with various pigments.

artist crayons

colored pencil drawing

black "marks all" pencils

Paper

There are many paper options, depending on how it will be used:

Sketch journal. If you simply want to draw or sketch out ideas, work on personal drawings, or doodle to your heart's content, use a sketch journal, such as one from the brand Moleskine.

High-quality cotton paper. Use this if you are more likely to turn your drawings into mixed-media art with paint, ink, and other mediums. Watercolorists most often use paper made from 100 percent cotton fiber because it's much more versatile. Inexpensive paper, such as student-grade paper, is produced using wood pulp and is acidic, which will eventually cause the paper to turn brown and brittle. Cotton papers are acid-free and therefore hold up over time.

Cold press paper. If you want a paper with texture or tooth, use this. Cold press paper has been rolled through cold cylinders, giving it a rougher texture than hot press paper, which is smooth from being ironed and flattened by hot cylinders.

Bristol paper. Thicker than average drawing paper, this paper is smooth and great for drawing fine details.

Pastel or charcoal paper. This tends to have serious texture, allowing for darker values in the drawing. Also, it is often tinted, which can really help to enhance your work.

Paper also comes in a variety of weights. A 90 lb paper is generally the thinnest available; a 300 lb paper is much thicker. A 140 lb paper is a popular middleweight paper. From handmade to synthetic paper, there are so many varieties of paper to try, so it is best to experiment to find a favorite. Mine is a 140 lb, hot press, 100 percent cotton watercolor paper that I use for almost everything I paint.

Other Supplies

In addition to those I just mentioned, other supplies come in handy: A craft knife is useful for sharpening pencils, and masking tape works well to mask a drawing's or painting's edges. Also keep on hand tracing paper, sandpaper, a drawing board or table, and a ruler, and make sure your workspace has good lighting.

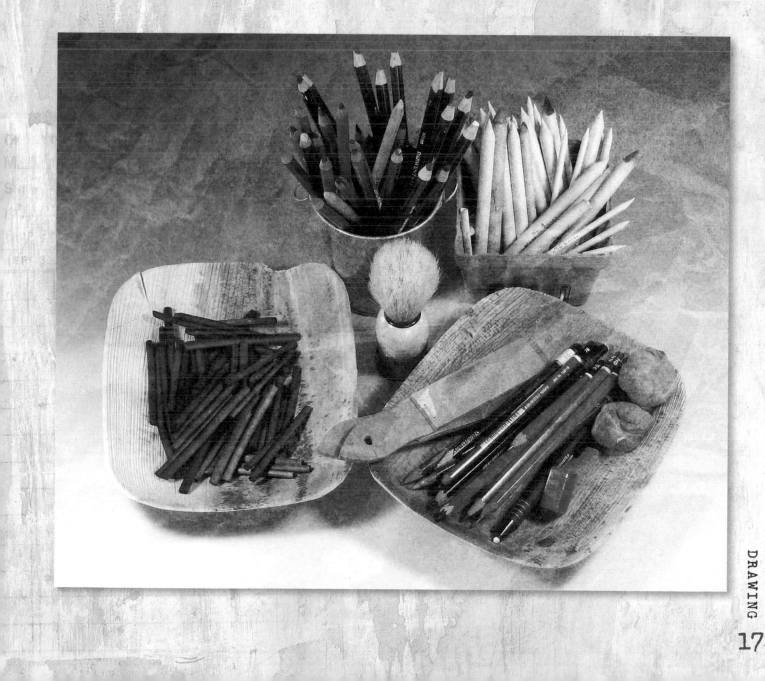

Expressing Yourself with Pencil

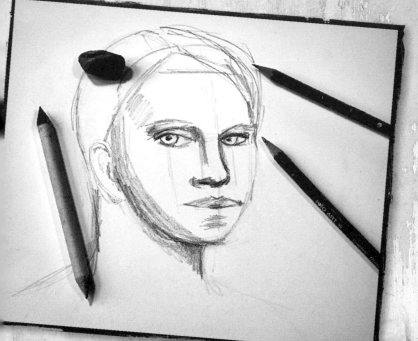

Drawing, like talking, singing, and dancing, is one of the first ways we learn to express ourselves. We start drawing lines and circles that depict or illustrate our story. With practice, these work together to make expressive, personal drawings. From there we add shading and make them three-dimensional, so they pop off the page. There is no right or wrong way to draw. Doodling many designs can feel just as rewarding as spending hours on a single realistic drawing. Anyone can draw. All it takes is a pencil, paper, and practice.

ELEMENTS OF SHADING

These shading elements are crucial to drawing realistic subjects. Here, they appear from darkest to lightest:

- **Cast shadow:** Where no light hits the subject. It is the darkest, blackest value.

- **Core shadow:** Where the subject begins to recede from the light. It is dark gray in value.

- **Halftone:** Neither light nor dark, this is the value in between shadow edge and highlight.

- **Reflected light:** The rim of light reflected from a surrounding surface back on the edge of the form. It is slightly lighter than the halftone but never as light as the highlight.

- **Highlight:** The brightest value of the drawing, where the light source is at its strongest.

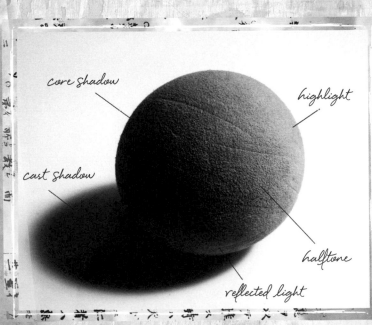

core shadow

highlight

cast shadow

halftone

reflected light

Light and Shadow

So your work doesn't appear flat when drawing realistically, keep these five elements of shading in mind: cast shadow, core shadow, halftone, reflected light, and highlight. To do this, you must understand your light source in relation to your subject. From which direction does the light shine? How does it affect and define the form you are drawing? With more than one light source at play, a subject can become visually distorted, which can cause confusion. Use one light source on your subject to help understand its values.

Here, light comes from the left side.

Multiple light sources shine on this onion.

Light comes from behind in this image.

On this onion, light shines from above.

value shading scale

Values range from light to dark. The method of applying these changes to create depth and dimension is called *chiaroscuro*. Master artists have used this technique for many years. The lightest value is called the *highlight*, in which the light hits the subject directly. The middle tone, the shade between the darkest and lightest, is called *halftone*; this area is neither in direct light or completely shadowed, and it gradually gets darker as it turns away from the light source. The darkest area is called the *core shadow*, which also includes an area where reflected light bounces off another form and into the shadow. This plays a large part in making a form look three-dimensional.

A shadow originating from the form onto a nearby surface is called a *cast shadow*. This can vary in intensity and crispness depending on the light, but because the form usually blocks the light, it is typically very dark. The cast shadow gives weight to the subject by providing it a surface on which to sit or lean.

highlight

core shadow

halftone

reflected light

highlight

cast shadow

Where to Begin

When trying to draw an object realistically, follow these basic steps:

1. Start off lightly sketching the shape of your subject. Draw guidelines or a grid to divide the shape, if needed. This can help you develop accurate proportions, for example, where the eyes should sit on a face, how they should line up with the mouth, where the nose should end, and so on. Start with the object's basic shape. For example, if you want to create an apple, first draw a circle, then define the edges as you work out the proportions.

2. Once you have the correct proportions, begin adding more details and laying in the shapes of the shadow areas. Hatching, or drawing in parallel lines close together, is the most common shading method. With a B or softer pencil, fill in the shadows with a light layer, building up the darkest spots one layer at a time, but leaving the halftones and highlights untouched.

3. Use a blending stump to gradually pull the shading into the half-tone areas. Pay close attention to the darkest and the lightest shadows. Leave the highlights untouched, if possible (you can always go back in with an eraser later).

4. Add the cast shadow, then use an eraser to pull out the reflected light area.

5. Use the kneaded eraser to soften spots that are too dark.

6. Pull out the highlights using the stick eraser.

7. Go back in and darken areas that need more contrast.

8. Finally, with the kneaded eraser, clean up any smudges or accidental markings.

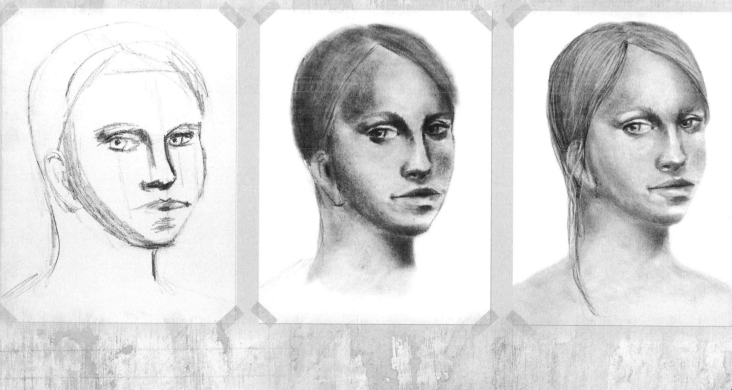

Portrait Drawing

Now that you understand the basic technique, why not try something slightly more advanced? To draw a portrait, follow these steps:

1. Start with the head shape; most heads are egg-shaped, narrowing at the chin. Draw the outline of the head and neck using a grid (like the one pictured on page 26) for accurate proportions.

2. Lightly lay down the shapes of the shadows and use the pencil to gradually darken the shadows and build up the tone, where needed.

3. Draw in the eyes, nose, mouth, and ears if you haven't defined them already with the shadows.

4. Fill in the nostrils, darks of the ears, and pupils with the darkest value, and leave the highlight areas white, if possible.

5. Using your blending stick, blend the shadows and add the halftone.

6. With your kneaded and stick erasers, subtract any highlights that need brightening.

7. Darken or lighten any areas that need it, and add details such as eyelashes, eyebrows, moles, and freckles.

8. Finally, draw in the hair, starting with a solid mass, then pulling out highlights with your stick eraser, leaving shadows between the highlights to make it look realistic.

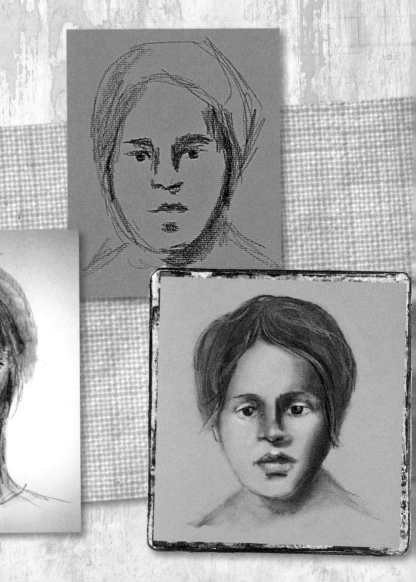

HERE ARE A FEW TIPS FOR DRAWING PORTRAITS:

- Squint your eyes to better see value changes when trying to read and define the shadow areas.

- Steer clear of hard lines when drawing realistically. Soft edges and subtle lines are more true to life than hard, contour lines.

- Draw the same subject several times, using different drawing tools or surfaces each time to see how they vary.

- Trace over an image using tracing paper to get a feel for an object's lines, or draw the shapes of its shadows.

- Look at your drawing from afar—frequently—to get a different perspective. This really helps illuminate where to focus attention.

- Practice! Practice! Practice! This is one of the best ways to become better at drawing.

- Observe. Spend hours noticing light, shadows, values, textures, and how they all work together.

Contour Drawing

This method involves drawing only the outline shape of your subject—the type of drawing children do—using hard lines without shading. Artists often turn to contour drawing to work through basic ideas; this method helps develop a good understanding of an object's shape and size.

For a wonderful warm-up exercise, try blind-contour drawing during which you draw by looking at your subject but not at your paper. This helps you let go of the fear of making a mistake and encourages you to draw what you see, not what you *think* you see. This can become challenging once we train our brains to "know" how something looks. Blind-contour drawings typically are not realistic, but they are expressive, lively, and often amusing. The more you do it, the better and more accurate these drawings will become.

Begin a blind-contour drawing by looking at the form of your subject. Place your pencil on the paper and slowly outline what you see with one continuous line, keeping your eye off the paper and on your subject. Take your time and draw what's in front of you. What happens when you finish depends on your end goal. Some drawings become paintings; some remain sketches in a practice journal. Drawing the same subject repeatedly can boost confidence and show real improvements.

DRAWING EXERCISES

Doodle. Doodling is for everyone. You can do it almost anywhere, and it's a great way to ease into drawing, get lost in thought, or work out ideas. In my opinion, everyone should doodle daily for good art health.

Need some simple exercises to get started? Trace your hand (or draw any shape) and fill it in with contour designs. Don't think too hard about making them perfect. They can be finely detailed or carefree, whimsical lines. Just keep your hand moving. Or take examples from objects around your house. Set up a light source on your subject and draw it, first using shading and blending, and then again as a blind-contour drawing.

• You also can draw a portrait. Use the grid to guide your proportions or sketch out the head shape and begin to define the shadows. Use a blending stick to soften and blend the halftone areas, and an eraser to pull out the highlights.

Fill a whole page with faces, each with a different expression.

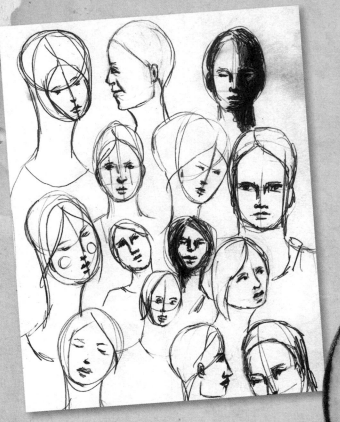

• Do several blind contours of the same subject, taking your time for every one and watching how each drawing improves. Fill your entire paper with drawings. Add color using artist crayons, and use water to soften and blend the colors (like you would do with watercolors).

• Using your STABILO Marks All pencil (or a sharp artist crayon), draw a portrait and then go in with a brush and water or soften the lines and create a monotone watercolor-effect painting.

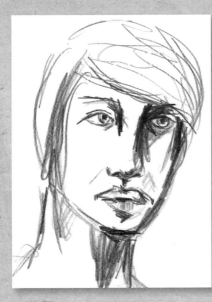 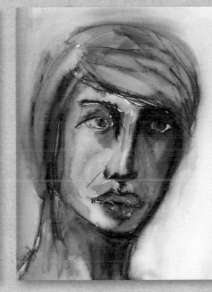

• Get wild and funky! Draw a portrait (a blind-contour or a more realistic rendering), then using your artist crayons, add as much color as you can and make your marks rich and heavy, until the entire drawing has been filled in.

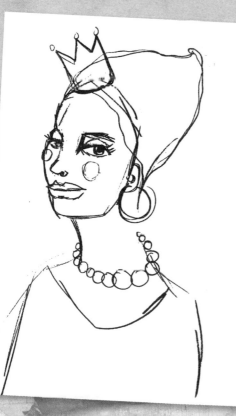 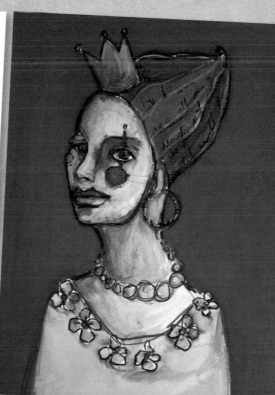

Painting

There are many types of paint—acrylic (fluid, heavy body, matte, glossy, student grade, high pigment), oils, watercolor, tempera—as well as practically infinite surfaces on which to paint, and hundreds, if not thousands of ways to paint. For a novice, these decisions and techniques can intimidate and overwhelm, possibly creating anxiety before the person has even picked up a brush. Art should not cause anxiety, but rather release it. A student receiving formal art training spends hours learning about art history, color theory, different perspectives, correct proportions, the design process, and the ins and outs of composition. These valuable tools could benefit any artist.

But no matter the number of hours spent learning about art, nothing compares to the hours spent with tool in hand, exploring different mediums, making mistakes, figuring out what works best for you to create art that speaks from the depths of your inner being. If you are brave enough to share your heart and soul and willing to make mistakes from which you can learn, the result will be art that evokes strong emotions from both artist and viewer and that tells a powerful story. Though the rules of painting can be useful for learning, remember that art rules should—and must—be broken to find your own way of creating.

paint on it you can."

—Danny Kaye

Materials

As with drawing materials, most art supply stores sell materials for painting. Check the "Studio Supplies" section of the Resources chapter on page 118 for information.

Acrylic Paints

Acrylics are water-based polymer paints permanent once they dry (and they tend to dry rather quickly, especially compared to oil-based paints). They come in matte or gloss, and they range from dull and thin to thick and vibrant, depending on the brand and quality of paint. One of acrylic's best features: It sticks to almost any surface, making it quite versatile.

"Through some memory, feeling, experience, into my palette; it mixes with my paint to do. I listen. I act on it."

Water-Based Inks

Typically used for re-inking stamp pads, these inks are a great addition to the mixed-media world because a little goes a long way. They are intense and colorful, they pull out detail and texture, and they also mix well with acrylics and crayons.

Golden Gel Matte Medium

This is an acrylic polymer-based gel similar to acrylic paint. Use it as glue, as a way to transfer images, or to add body to acrylic paint.

Gesso

Gesso, a mixture of glue and plaster of Paris, comes in white, black, and clear. It prepares the surface much like a primer does a wall. It can add a nice tooth to the surface or be used over a painting gone bad, creating a fresh surface on which to start over.

bottle of ink

Brushes

I consider getting a new set of brushes as exciting as receiving a new book or buying a great pair of shoes. But with the millions of brushes available, how can you know just which one to use for which technique or effect? Certain brushes work better with acrylics than with oils or watercolors (the package should state the brush's intended medium), but the best brush is truly the one you as the artist most prefer. More often than not, this discovery comes through trial and error.

Brushes range drastically in price, from just a few dollars to hundreds. Working in several mediums at once makes it hard to justify an expensive set of brushes. So, if you're just starting out, I recommend buying a variety of brushes. They come in all shapes and sizes: There are foam brushes, stencil brushes, script brushes for writing, short handles, sable, synthetic, flat, round, fanned, an endless list's worth. A long-handled brush allows you to work farther away from your painting, which often helps you gain perspective. A scrap of mat board (typically used to mat paintings), a palette knife (often used to mix paint or paint with), or your fingers also make wonderful painting tools; using them to move paint gives your piece a different look than that from a brush. Explore painting's many options, get messy, and have fun!

the passion wells up and spills
And the paint tells me what

—Ann Dettmer

Where to Begin

Choose a surface on which to paint: wood, canvas, paper, a wall, anywhere really. If you choose a surface not designed for paint—which is absolutely acceptable—it's best to gesso the surface first to make sure the paint will stick.

Painting with acrylics allows your surface to vary greatly, making it possible to paint on anything from shoes to glass to cardboard. Each surface reacts differently, but testing and understanding your medium is part of the process. Try a variety of surfaces to see which creates the best foundation. Keep in mind the finished product and how it will be displayed. Most paintings on paper get framed behind glass, whereas most canvas works stay exposed.

The brushes, surface, and paints are ready. So what should you paint? A portrait? Backgrounds? A still life? One of each?

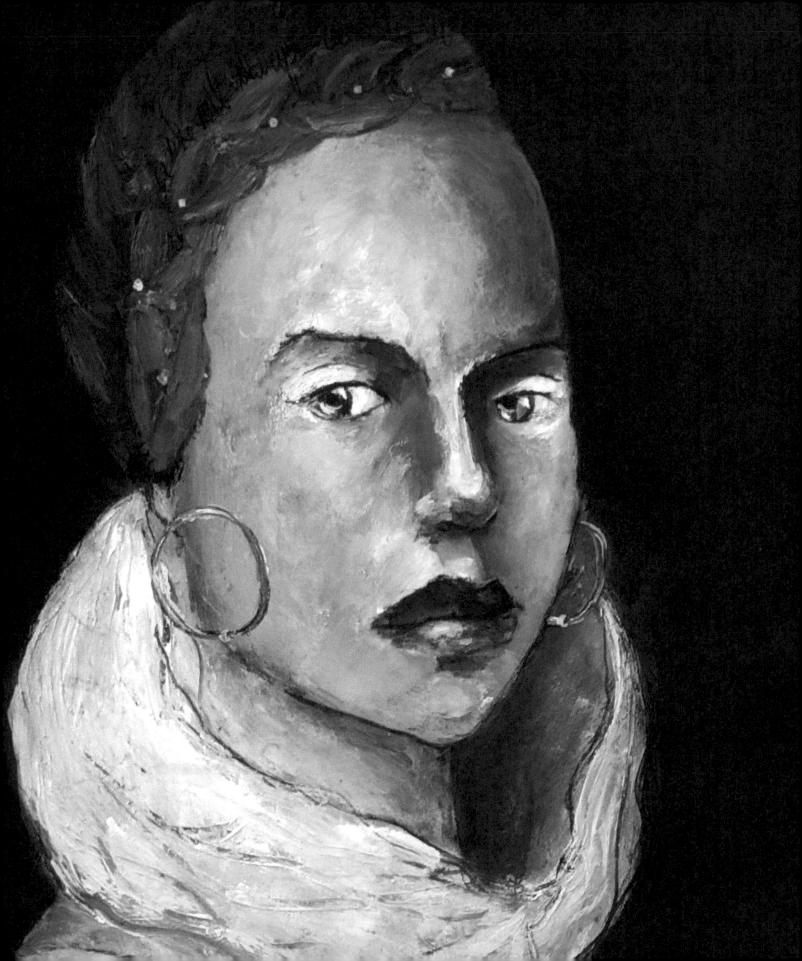

> *"Seeing likeness in a portrait is to recognize the craftsman in the artist. Finding soul is to discover the artist in the craftsman."*
>
> —Bernard Poulin

Portrait Painting

Before painting a portrait, sketch out a drawing. Lightly lay in the shadows as a guide for painting. To create a likeness of the subject, pay close attention to the proportions of the head and the features, as well as to the overall facial expression. However, it's more important to convey someone's personality and character than exact eye or mouth size, for example. The drawing done prior to the painting will be a good indication of the likeness to the subject model.

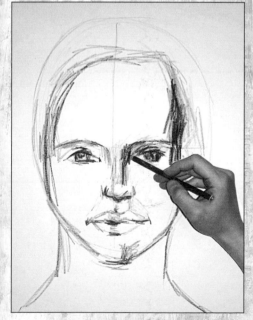

sketch of a portrait for painting

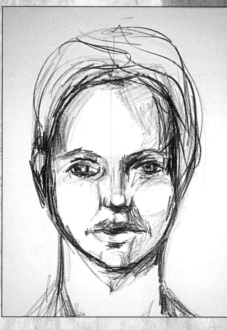

sketch of a portrait for painting 2

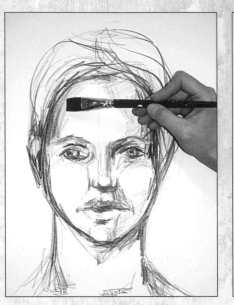

sketch of a portrait for painting with brush

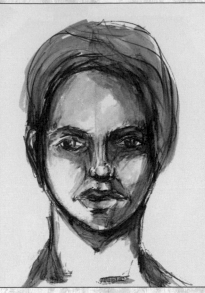

sketch, with underpainting

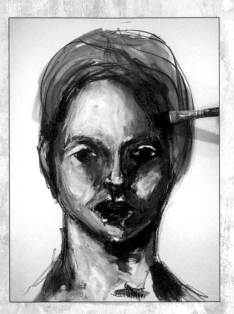

painting in the shadow areas first

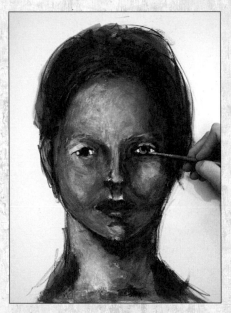

continuing with layers, highlights, and details

After the drawing, follow these steps:

1. Start painting with the darkest flesh tone, and much like drawing, lay down the shadows first. Pay attention to the light source, proportions, and shape and color of the shadows.

2. With the darkest shadows still damp, use a damp brush to pull out the dark tones into the lighter areas, creating an underpainting (the underlying foundation over which you will eventually paint).

3. Begin to add titanium white, which is opaque and will pick up colors already down, creating a thicker skin tone.

4. Continue to soften the skin color as needed by blending the darker tones with the light. Work around the face all at once, adding white to the lighter areas, especially in the highlights, leaving the darkest tones dark.

You won't need much water for this process other than to clean your brushes or to rewet your paint. A damp rag works perfectly to moisten the brush as you go.

Often a painting reaches a point at which the artist thinks it is not salvageable. Keep with it, and it will work itself out. Continue refining the portrait by focusing on finer details such as roundness of the pupils, shape of lips, nostrils, ears, or hair highlights. After the face, paint the background. Remember, like all other artistic techniques, painting portraits takes practice.

"What a joy it is to capture the likeness of another human being. It has been said that the eyes are the window through which we glimpse the soul. That's my favorite thing to paint—souls!"

—Ann Manry Kenyon

continuing with more layers

painting the background

finished piece

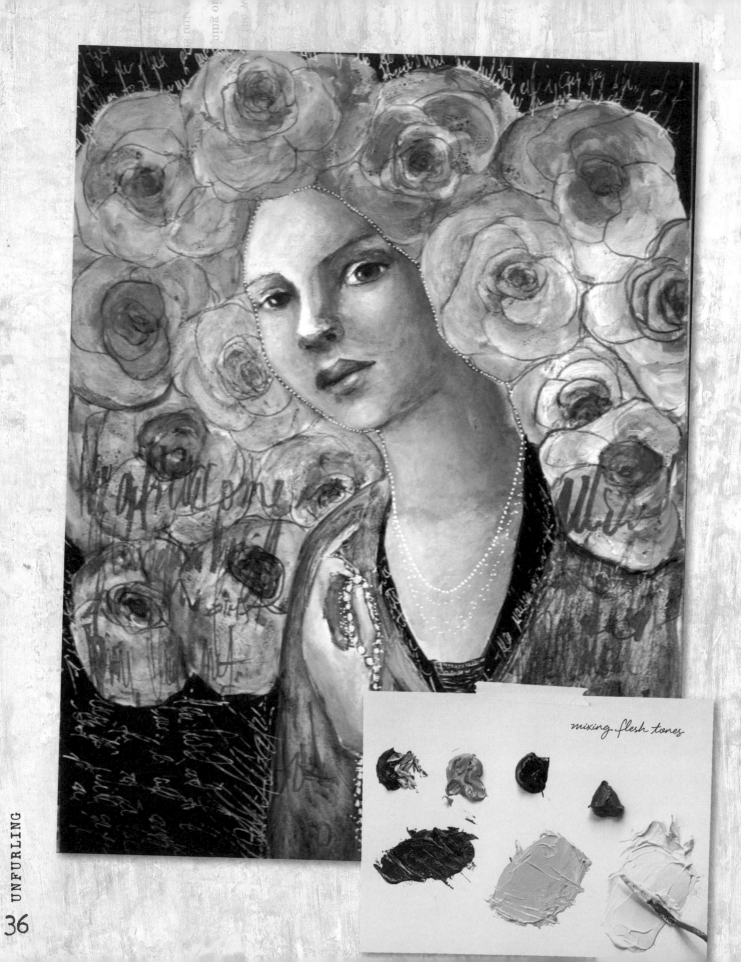

mixing flesh tones

Mixing Flesh Tones Using Acrylics

Flesh-colored paints are readily available, but they aren't nearly as much fun as mixing your own. Create these tones using a variety of colors (your palette will differ from that of another artist). To mix flesh tones, start with equal or slightly varying parts Payne's gray, quinacridone nickel azo gold, crimson, and yellow with titanium white, to create the darkest value. Make modifications when necessary. For example, for a cooler flesh tone, add more Payne's gray. For a warmer flesh tone, add more nickel azo gold. For a darker skin tone, add more Crimson red mixed with a small amount of Payne's gray and Quinacridone Nickel Azo Gold. Blend them to achieve the darkest tones for the shadow areas. Add small increments of titanium white for the halftone, highlights, and reflected light areas.

For the lips, eyes, and hair, tweak the flesh tone you already created: Add red for the lips, blue, green, or brown for the eyes, quinacridone nickel for light hair, and Payne's gray mixed with Quinacridone Nickel Azo Gold for darker hair. Lighten and dull the flesh tones with more titanium white or titan buff, when needed. To darken flesh tones, add more of the dark tones already created, using Crimson, Payne's gray, and Quinacridone Nickel Azo Gold.

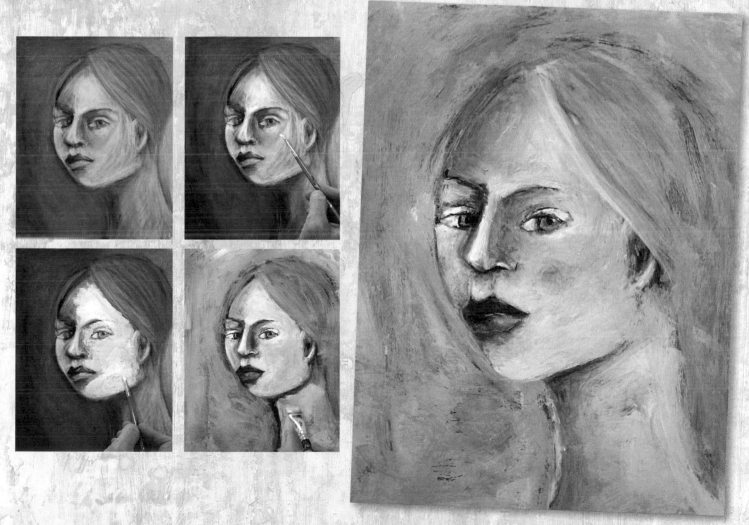

EXERCISES FOR PORTRAITS

As I already mentioned, painting takes practice. Here are a few ideas to improve your portrait-making skills:

• Paint a monochromatic portrait using white and just one other color.

• Create a self-portrait of you as your favorite animal instead of as a person.

• Use water-soluble crayons to draw and heavily color in a portrait, then paint over top of the crayon drawing using only titanium, blending the colors slightly.

• Draw a portrait using the black STABILO Marks All pencil, then paint over it with titanium white.

Background Painting

When painting a background, I have no expectations about the appearance of the finished work. It is more about exploration, about seeing how it will unfold. Like a fearless child without hesitations, I find gratification in diving head-first, painting a background before deciding on my final layer or look. It is far easier to scope out what works for you as a painter when you release any reservations, allow spontaneity to take over, and do what feels right.

"Painting, to me, is a unique experience. Each has its own personal and intuitive meaning. After and memories, each one of my paintings evolves

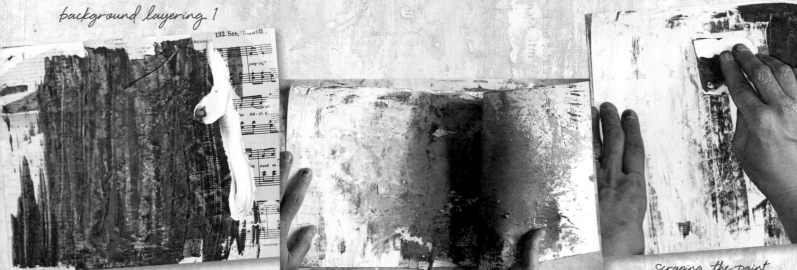

background layering 1

layering the paint

blotting the paint

scraping the paint to gain texture

Layer Painting

You can easily create backgrounds full of texture and design by using a handful of ephemera, a variety of stencils, rubber stamps, acrylic paint, inks, and gel medium. I prefer to work on watercolor paper, wood, or unstretched canvas because they allow for applying as much pressure as I want without having to worry that I will stretch out or warp them.

On your surface of choice, apply a dollop of paint and move it around using a cardboard scrap or an old credit card. Add a bit of white or another color; then, using a sheet of watercolor paper or a page from a magazine (I prefer the latter because of the ease with which it lifts off and moves the paint around), blot the surface over and over. Continue moving the paint around, scraping, blotting, and creating a soft texture while gradually blending together the colors.

Add color until you deem the layer complete. One layer does not have to be completely dry before adding the next. I tend to work while the layers are damp, but not sopping wet or too thick. If the paint becomes muddy—this can happen when complementary colors such as red and green, purple and yellow, or blue and orange get overblended—scrape it off and start again. Unsure which colors mix well? Trial and error is one way to learn; using a color wheel is another.

work is a surprise and brainstorming feelings freely and independently."

—Fernando Araujo

COLOR COMFORT ZONE

Every artist has a comfortable palette, but don't be afraid to expand beyond this zone. Colors can tone down or liven up a painting. They determine whether a painting will be soft and soothing or wild and vibrant. I tend to paint with a mild color palette, leaning toward cooler tones. But every so often, it feels good to shake things up by using intense colors that bring my work a splash of warmth. Give it a try.

background layering 2

moving around the paint

lifting the paint off
with a damp cloth

Limitless Layers

After the bottom paint layer, where to go next? The second can be more paint, collage, inks, designs, or all of the above. The sky's the limit! Once I create a layer or two, I typically add a layer of designs, overlapping different stencils, stamps, and paints. When using stencils, I usually apply paint or ink to pull out the design. Sometimes, however, I wipe a wet cloth across it, lifting off rather than putting down paint in the cut out. I stamp rubber stamps in ink or paint and then press them onto the background. Using paint creates more texture than ink.

Or for the next layer, why not try water-soluble ink? It's great at this stage of your work for pulling out the painting's textures and detail, and a little goes a long way. Add a few drops to the painting and scrape, blot, or wipe until the ink settles. Then take a damp rag and wipe a thin layer off the top, adding contrast to the textures from the paint by lightening the light areas while leaving the darkest values dark.

Here's one more option: Glue down textbook pages or sheet music, then apply a layer of gel medium, place the gel-covered paper on your surface, and force any air pockets from under the layer using a scraper or brayer. Pull up a layer here and there to gain a layered texture. Do this by tearing a small piece of the glued page up. Add layers until you reach your desired texture. If too much lifts off, add another layer, more paint, stencil designs, or ink, working each layer onto the next with scraping or blotting. This technique gives the painting a weathered look, like the wall of an old house with many wallpaper layers. The finished piece is a richly textured, beautiful work of art.

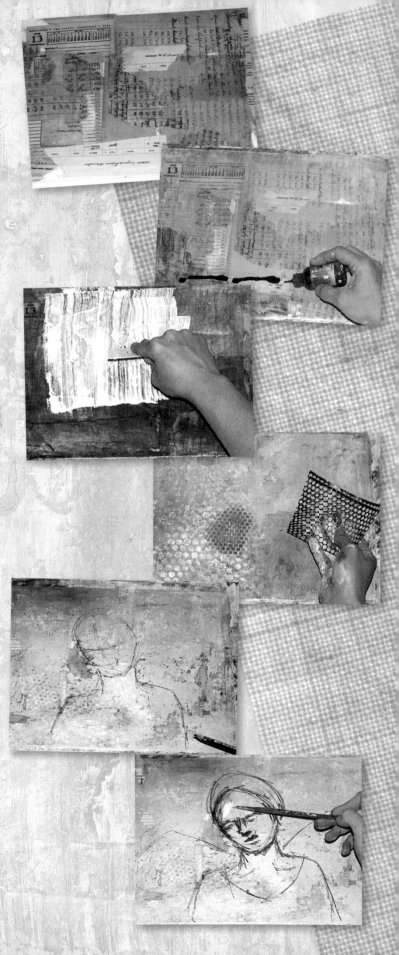

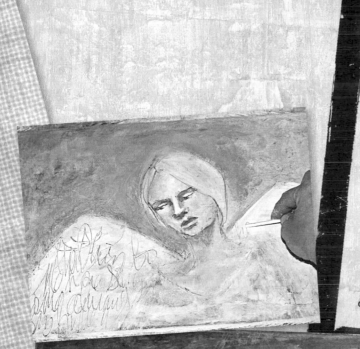

CREATIVE LAYERING

Look around your space. What other material and tools can you use to add designs to your painting?

• Dip the cap of a marker in some paint and stamp it repeatedly on your page, creating a cool circle design.

• Paint a handful of rubber bands, leaves, straws, the lid from your paints, the end of a paper towel roll, the sleeve from a hot cup of coffee, anything.

• Glue down textbook pages, sheet music, ephemera, old letters, any interesting paper, then rip off part of the page, creating a perfect torn texture on which to paint.

• Be innovative and keep your mind open to endless possibilities.

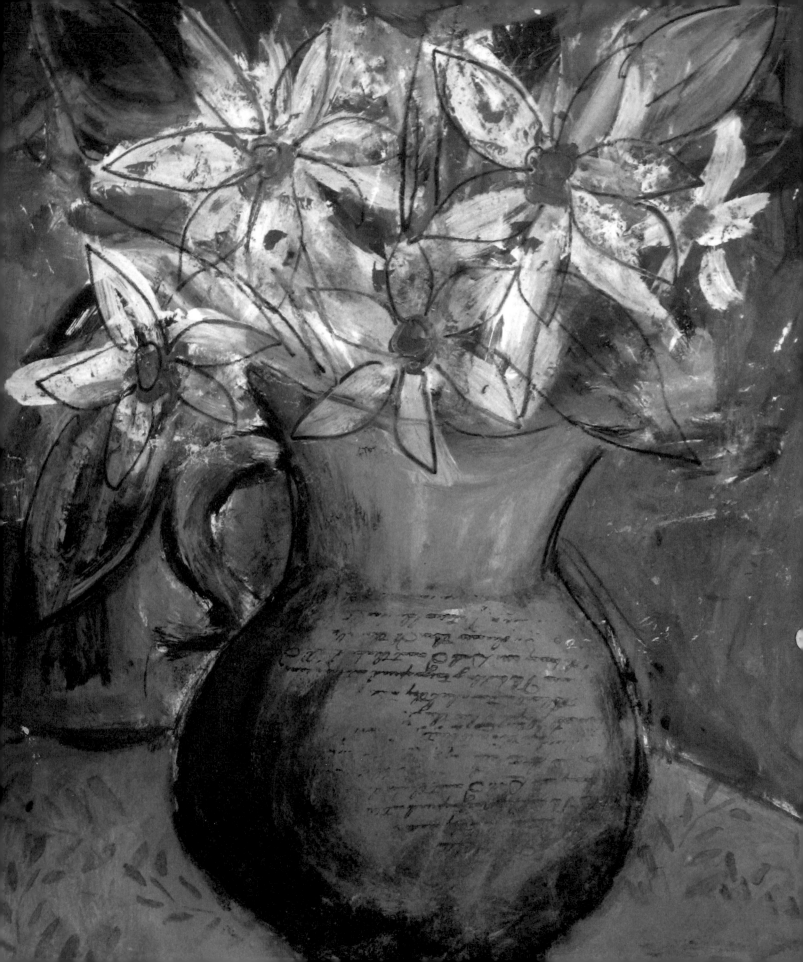

"Every artist dips his brush in his own soul, and paints his own nature into his pictures."

—Henry Ward Beecher

Still Life

Much like when I paint a portrait, when I paint a still life, I try not to get too caught up in re-creating a realistic representation. Rather, I try to convey an expression or emotion, to evoke personal feelings in myself and by the viewer. A still life can be as simple as a piece of fruit on a table or as elaborate as a display of unusual objects in an aesthetically pleasing arrangement.

Whatever the subject, do a few preliminary sketches before painting to get an idea of placement, object form, proportion, and composition. Pay attention to how the objects relate to each other, and choose one against which to measure the size and placement of everything else. Create a horizon line to

ground the subject, as well as add depth and determine the vanishing point. Also, keep in mind composition. In other words, make sure to select a focal image that pulls the viewer into the painting. Make it large, close to the center, and visually appealing. Poor composition can be the death of a painting and often results from too many conflicting ideas or an unbalanced subject.

With a solid sketch in hand, you are ready to add paint. Work on a previously painted background or start on a fresh surface. Keep the sketch in view for reference or paint over it as your guide. Whether you first paint the background or the forms doesn't matter, but pick a background color that contrasts yet complements the still life and makes it pop. I recommend beginning with the largest forms first, just like in painting a portrait, and pay close attention to the colors, shadows, and highlights. These all give life to the still life.

STILL LIFE EXERCISES

Try these exercises to work on your still life skills. Create one or more of the following:

- traditional still life painting, sketching it out first

- nontraditional still life using silhouettes and collage elements

- blind-contour still life sketch, then painted

- still life using only artist crayons

More playful ways to approach a still life are to use only collage, elements of collage, or a mask cut into the shape of your object to create a silhouette. Or take a photo of a still life, print it out, create an image transfer, and paint over it. (For details about image transfers, see the "Gel Medium Transfers" section of this chapter on page 51.)

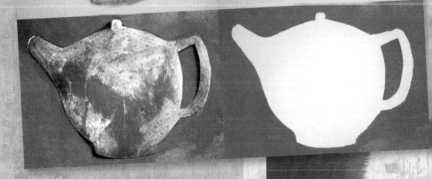

USING A MASK

Cut out one or many elements to use as a mask, a stencil or barrier that blocks an area from exposure to paint. These could be anything from something you drew to funky silhouettes from a magazine to several random shapes that together create a form. The example included showcases a cutout of a teapot drawing done on scrapbooking paper.

Put down the cut out mask on the painting where the image will appear. Place a sufficient amount of acrylic paint on the middle of the mask and begin spreading it out using a scraper or cloth, holding the mask in place so no paint gets under the shape's outline. Continue moving the paint outward until it has spread far enough from the mask's edge. Gently lift up the mask to expose the unpainted shape below.

"Creativity, it has been said, consists largely of rearranging what we know in order to find out what we do not know."

—George Kneller

COLLAGE

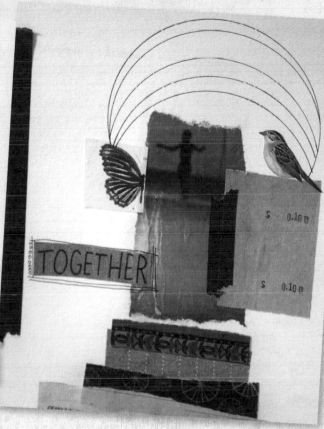

Collage

Collage comes from the French word *coller*, which means "to glue." Pretty simple idea, right? It can be.

Collage can be painlessly uncomplicated and straightforward or extremely complex. An artist can glue down one image on a blank paper to create the beginnings of an amazing journal page (for more about this topic, turn to the Journal section of the book, starting on page 84). I like to think of this method as planting a seed, one ready to germinate, sprout, and blossom into something more, something spectacular. There's no plan or exact path other than to give the seed what it needs to grow: paint, ink, words, more collage. The final image comes together to become a field of beauty.

A more meticulous and thought out method turns an idea for an elaborate painting into a collage. This requires precise planning, using thousands of collage elements of every shade cut and torn then glued to a canvas to create a beautiful work of art.

These two methods fall on opposite ends of the collage spectrum. There are many others in between. One guarantee—and an aspect I absolutely love about collage—is that no two works ever end up the same. Such mystery lies in its possibilities. It's also quite a forgiving medium, which makes it even more enjoyable for any blossoming artist. Putting together pieces of paper to create interesting designs has been a way of creating art since the invention of paper; it is still a favorite method of expression.

Materials

Unlike with drawing and painting—and like the collage medium itself—the tools to create a collage are simple:

- regular gel matte medium, such as GOLDEN brand
- scissors
- paintbrush of any kind
- scraper
- collage materials: old textbook pages, sheet music, scrapbooking paper, art book pages, patterned paper, newspaper cuttings or old pamphlets, photographs, printed images, wallpaper, doilies, and practically anything else that you can glue down

Cut It Out!

Your collage materials are set. Now, find a starting image. It doesn't need to be a strong image; it could just be a scrap of colorful paper or a fortune from a cookie. Place the image on your work surface and begin surrounding it with collage elements. Move around pieces until you feel satisfied and ready to glue.

Glue away. Once everything is down, add more color using crayon, ink, and markers. Paint around an image to make it stand out more, or paint over the collage, altering it, and making the borrowed images completely your own. Continue incorporating elements until the work feels complete. How do you know when that is? You love it!

Take a picture before gluing down your collage pieces. This way, you know where you had everything placed.

Gel Medium Transfers

Before going further about collage, a brief interlude is needed to talk about one of my favorite techniques: image transfers using gel matte medium. Gel matte medium is an acrylic polymer-based gel similar to acrylic paint. It can be used as glue and as a way to transfer images (a variety of methods work to transfer images, but gel is the most responsive)

Transferring an image basically means gluing it face down, then removing it to expose its mirror image. This method, rather than just gluing down an image as collage, removes a paper layer, unifying the image to your design and creating a flush surface on which to work. Plus, there's something satisfying and addicting about transferring an image to use as a collage element.

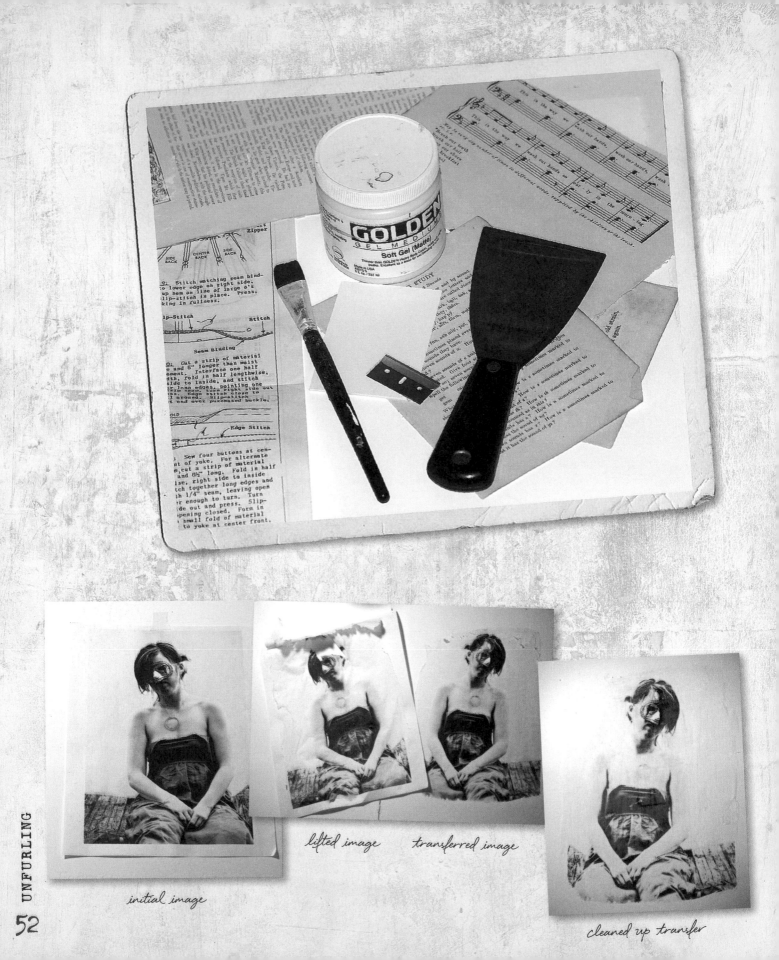

initial image

lifted image transferred image

cleaned up transfer

Most images—save for real photos, glossy images, or images printed with permanent ink—will transfer using regular or soft gel matte medium. (I've had the most luck with GOLDEN brand.) The best way to know whether something will transfer is to try. If it is an image about which you care deeply, take a photo of it, print it out, and use that version instead of the original. Images printed out at home on basic white paper using an inexpensive inkjet printer tend to transfer perfectly every time.

To transfer an image or text that contains words, mirror the image before printing so the words face the correct direction. You can usually do this within your printer's settings. Pages from old books or magazines, handwritten letters, and sheet music transfer well most of the time. If your background is dark and you wish to make the image more visible, add a layer of white paint or gesso to the spot where you will transfer, and allow it to dry. If the image does not transfer properly, scrape off the gel and try again. Some images are more stubborn than others and won't transfer at all. If this happens and you really want to include the image, glue it down as collage.

Often when creating painted backgrounds, I prefer to start on a surface covered with a layer of texture, especially a layer of images fully or even partially transferred. This surface type grabs hold of the paint and pulls out the texture from the gel medium and glued down text pages

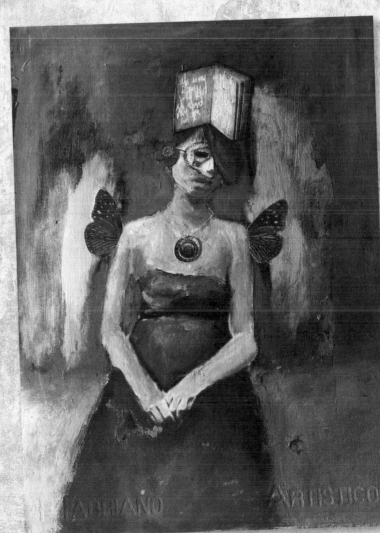

painted transferred image

Here's the step by step on how to transfer an image:

1. Apply a layer of gel medium to the image you wish to transfer and immediately place it face down onto your surface.

2. Brayer or scrape the air pockets out from under the image. This also moves around the gel, making sure it covers the entire surface. Allow the image to rest for up to 1 minute. For a damp and porous surface, let it sit for slightly longer.

3. Lift the corner of the paper and slowly peel it back. At this stage, the image has transferred if it's stuck to the surface and the paper lifted off is a faint image of what it was. If it has transferred, peel off the entire paper layer.

4. Rub away with your fingertips the paper residue on the transferred image. Do this gently. Sometimes, much paper will remain on the image; other times, it will be a thin layer. Rub until you feel the smooth surface of the image transfer. If you apply too much pressure or rub too quickly, the image will buckle, so be gentle. Once you do it a few times, you'll get a feel for this step.

5. Add layers to the transferred images, bits of collage, lace, ribbon, paint, or simply leave it as is.

Anytime you add gel medium to a surface, it creates a barrier and helps to seal the transferred image. If the bottom layer of a transferred image gets too buried, sand the top using semifine grit sandpaper. This can bring the image back to the surface and make it visible again. This works wonderfully to create backgrounds with a distressed look, like the outside of an old house left unpainted for years. Adding a small amount of ink or paint to the sanded surface harmonizes the exposed surface with the rest of the piece.

1. Apply gel

2. Remove air pockets

3. Peel up paper

4. Remove top layer

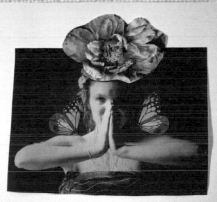

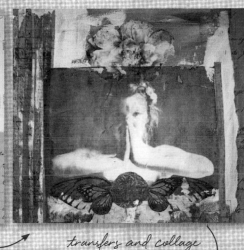

starting with an image *adding collage* *transfers and collage*

Stretching Out an Idea

Collage is easily my favorite part about creating art. Since I was a child, I have been cutting, ripping, and pasting together bits of paper to create original, expressive imagery. To this day, I love making collages and looking at the work of other artists who favor collage, such as Sabrina Ward Harrison, Teesha Moore, Dan Eldon, and Candy Jernigan. (See the "Artists" section of the Resources chapter on page 118 for their websites.)

Collage is comparable to putting together a dinner. I start with the component I most want to use, whether that's a main dish or a single ingredient. I cook the meal's remainder guided by what does or does not complement the single ingredient. With collage, one inspiring image—from a photo book, an old letter, a personal treasure—guides the rest of the piece. I consider and work around its design, color, and shape. Sometimes I like to see just how far I can stretch one image, where it will take me, how it will grow, and what it will become. Often the final result ends up far from where it started (at times, visually losing the initial image in the rest of the work). However, that initial image still sits at the core of the piece.

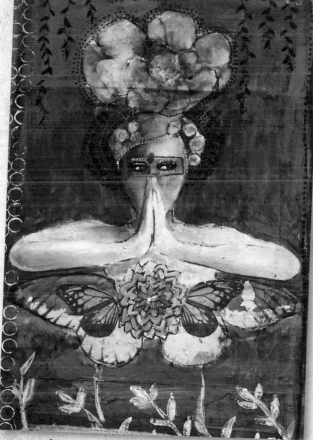

painted over collage

" *Art is not so much expressing oneself as it is discovering oneself.* "
—*Anawanitia*

MAKING A VISUALLY FABULOUS COLLAGE

Keep these aspects in mind when creating your collage:

- **Focal point**: The main interest or central activity that draws in the viewer.

- **Proportion**: How one element relates to another. For example, avoid making your focus a tiny image on a huge background unless the collage includes other supporting elements.

- **Value**: The lightness or darkness of a given color. A strong collage includes many contrasting values.

- **Shape**: Areas in the piece defined by edges. They can be geometric or organic (natural, curved, and flowing).

- **Line or direction**: The visual path a viewer's eye takes as it moves over the piece. This should end on the focal image, not somewhere that will lead the eye to wander off the page.

- **Perspective**: The art of drawing solid objects (three-dimensional) on a two-dimensional surface to give the actual or correct impression of their height, width, depth, and position in relation to each other when observed in a particular direction.

- **Rule of thirds**: An imaginary grid or guideline that divides the piece into three equal columns and rows, creating four intersections (nine equal parts). Keep your focal images on or near the intersecting lines to create a more aesthetically pleasing composition.

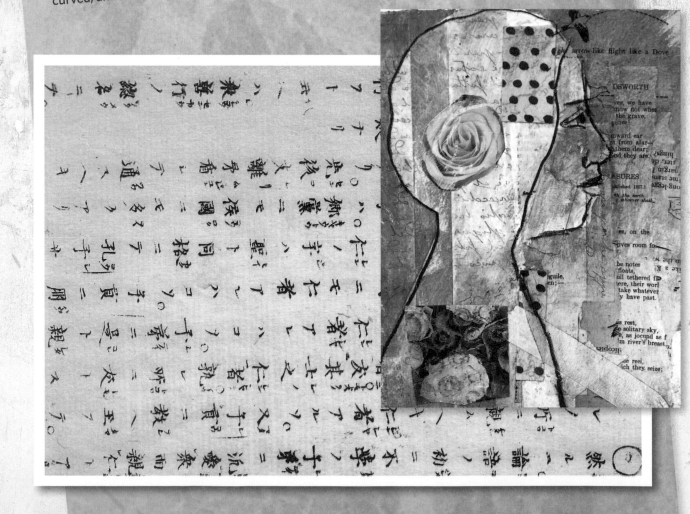

Torn to Pieces

Create a portrait mosaic using pieces of collage. Tear out ten magazine pages that share the same colors, but have different and interesting textures and that range in tones from light to dark. Some combination of facial-feature images—eyes, nose, ears—may be helpful, too. Rip or cut up the pages into pieces, placing them into three piles: dark, halftone, and highlights. Using a photograph or image as a reference, sketch a face on watercolor paper, canvas, or in a journal. Once a suitable drawing emerges, glue down the darkest areas first, then the halftones and the highlights. Create textures and use images and colors to your advantage. Refer to the photograph as needed.

Once you are comfortable doing this for a portrait, expand on the technique and create other types of images.

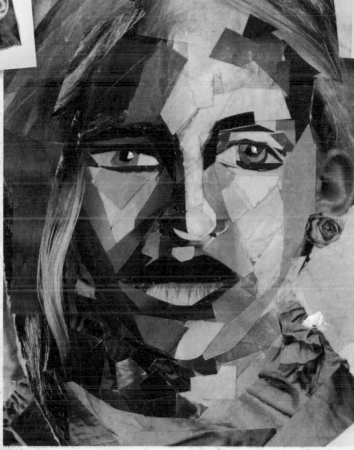

"Our self - expression is meant to be a manifestation of the silence of our hearts."

—Matthew Fox

COLLAGE EXERCISES

Here are a few exercises to practice collage techniques:

• Glue one image to your paper, then draw and paint over it, altering it as much as possible.

• Create a layered collage, filling the entire page with collage elements and adding more layers of paint, ink, and crayon to pull out the layers underneath.

• Transfer an image and paint over it, making it your own. Then add collage to accessorize the painting.

• Make a mosaic portrait using hundreds of collage bits.

• Create a background using image transfers, ephemera, and text pages.

• Select a focal point, then work with and around that image.

• Choose a single color, then build a monochromatic collage using many of its shades.

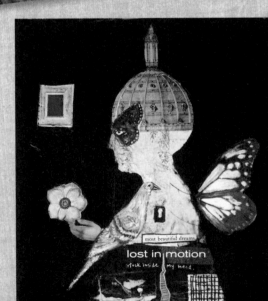

Finding Your Own Style or Voice

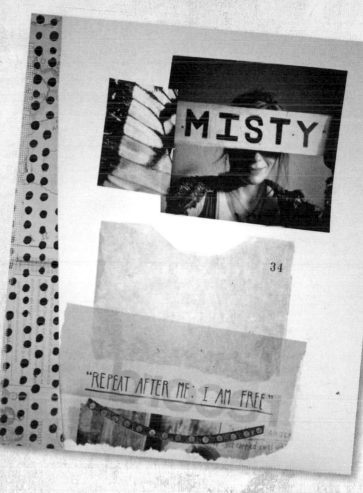

How can you take these techniques further to create work from the heart? Artists just starting out—and those who have been making art for years—struggle with this. Every artist wants a unique finished product, one that sings a tune yet to be sung. But these days it seems that everything has been somehow recycled into art. So how does an artist discover his or her own style or voice? It is not as difficult as it seems.

Of course, paint as frequently as possible. But also, stay true to what you love and always keep searching. As an artist, never let "ordinary" satisfy (unless, of course, ordinary is what you truly love). Stretch out ordinary, toss it up, squeeze it, splash some color on it, and stretch it out some more. Most importantly, make it your own. The works you produce initially may not be up to your standards, but that is completely okay and normal. When I think back to the art I created when I was just beginning, part of me wants to cringe. But another part beams knowing how far I have since come. With time and practice comes great progress.

What I love about making art (or any creative activity) is that by the time I finish, the work usually has transformed from one idea into something completely new and different. Allow yourself to move from one idea to the next without fearing what you may lose. Instead, go with the momentum to see what you will gain.

"To be successful, the first thing you must do is fall in love with your work."

—Sister Mary Lauretta

craft |ˈkraft|

NOUN: an activity involving skill in making things by hand

I waver back and forth between calling myself an artist and calling myself a crafter. If I had to pick just one, I'm not sure I could. I love making art to tuck behind glass and frame for a wall, but I also love creating tactile objects that are both functional and not, that anyone can pick up and handle over and over. Luckily, I don't have to choose between the two. As it so happens, they go together well.

Crafters have been crafting since the beginning of time in many far-ranging mediums. They've created utilitarian clay pots for water and food, and woven rugs and clothing for warmth and protection. They carved and built intricate woodworking. They even created religious artifacts. The list is endless.

In today's mass-produced world, crafting is firmly holding its ground as more people realize just how precious it is to create with the hands and from the heart. These creations—the little coil pot made by tiny fingers perfect for holding treasures, the quilt sewn a lifetime ago that still has stories to tell, the hand-felted slippers oh-so-toasty on a winter's day—hold great value to us. How can a mass-produced, impersonal anything compare?

Crafting can be a calming, peaceful activity with enduring meditative benefits. And just as in creating art, crafting's end product is one reward, but so is the process itself.

"Crafts make us feel rooted, give us a sense of belonging, and connect us with our history."

—Phyllis George

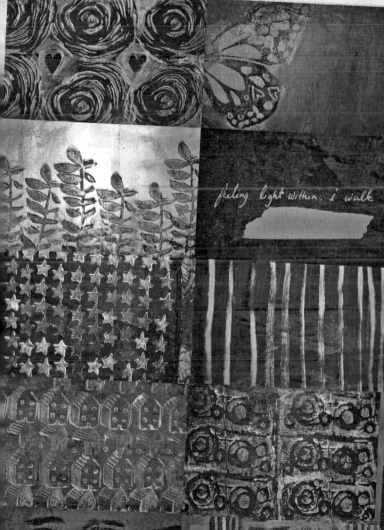

Stamp Carving

Add your own style and design to your work by carving your own stamps. It is easy, enjoyable, and inexpensive, not to mention highly addictive. Once you start, you won't want to stop! Your carved stamps can range from a basic shape to much more elaborate designs, depending on how you want to use the stamp. More artists and crafters have begun carving stamps to add their personal touches to letters, art, and craft projects. Stamps can be used with inks, acrylic paints, watercolors, clay, and much more.

Materials

Carving stamps is simple and fun, but you need the appropriate tools:

• rubber carving block, such as Mastercarve by STAEDTLER, erasers, corks, or potatoes
• tracing paper
• soft (2b) pencil (see page 13 of the Drawing chapter for details about pencils)

• bone folder, a smooth device made from bone or plastic typically used to crease edges
• linoleum cutter with two or more tip sizes
• razor blade or craft knife
• cutting mat
• designs to trace
• ink or inkpad
• acrylic paint
• paper or a journal

until I set him free."

—Michelangelo

Finding the Right Design

If it is your first try at stamp carving, keep it simple and work your way up to more detailed stamps. Designs are everywhere, from nature to the Internet to your imagination. Feel free to get started by using those in the "Templates" section of this book, beginning on p. 120.

Once you pick a design, trace or draw it onto tracing paper with a soft pencil. Turn the design upside down onto the rubber block so your pencil marks face down. With your bone folder or a credit card, rub the backside of the tracing paper just enough to transfer the image onto the rubber block. Lift off the tracing paper and you are ready to carve. If you decide to create letter stamps, keep in mind that with this transferring method, your letters will appear backward on the block, but will show up correctly when stamped. If you choose to draw your design onto the rubber block, make sure it's backward before you begin carving so the stamped image will be the correct direction.

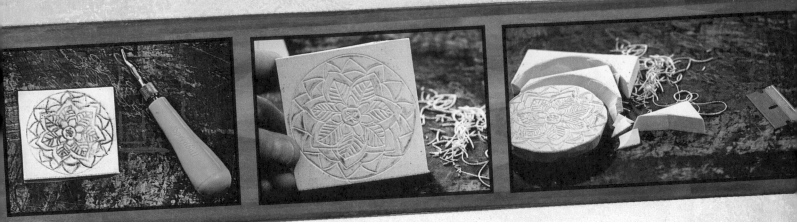

Carve Your Heart Out

The design's ready to go. Now it's time to carve.

First determine whether you'll need a fine tip for intricate details or a wider tip for a looser design. Typically, it is best to start off with a finer tip and work up to a wider one. Remember that anything carved away will not show up when stamped. Determine ahead of time whether to concentrate on removing the design's positive space (the drawing itself) or the negative space (the space surrounding the subject). What makes sense depends on the finished image you want to stamp. For example, if you're creating a word and you want the word itself to stamp, carve the negative space. If you want the space around the word to stamp, carve the positive space.

If carving negative space, start by cutting around your design, first outlining areas that will print and then carving out areas you wish to remove. To keep the negative space unstamped, reverse the method and first cut away the positive space. Make shallow cuts initially, until you firmly establish the areas to leave alone. Then go back in and deepen the cuts. Take your time to ensure no accidental carving into incorrect areas.

TIPS FOR CARVING

• Always carve away from yourself to reduce the chance of getting hurt.

• Test your stamp midway through carving to see how it's going. Stamp your block. Does it look how you want it to or do you need to keep working?

• Let nature be your design. Find inspiration in a leaf or a flower.

• Move the rubber block more than you move your carving tool when carving a stamp.

• Carve each side of a block into a different stamp so you don't waste material.

• Clean your stamps (gently) with soap after each use. This will help them live a long life.

Stamp with Paint

Stamping with ink creates a crisp, easy-to-love image, but stamping with paint brings a whole new appeal to carving stamps. It tends to create less-than-exact images, allowing an artist to be more daring and less attached to perfection. Frequently, this makes for a more visually interesting design. An artist can use one stamp over and over again or use many at once on a painted background.

stamped & painted

painted

MY LITTLE BOOK OF STAMPS

I wanted to create a book inspired by the beautiful Japanese shibori indigo fabric a friend recently gave me. The deep indigo fabric with its little splashes of white circles creating the perfect design captivated and inspired me. Plus who can resist a handful of freshly carved stamps waiting to be tried?

I gathered my materials:

• a little journal (this can be handmade or store-bought)
• acrylic paint (either titan buff or titanium white)
• water-soluble indigo blue ink
• an expired credit card (or piece of mat board) for scraping
• razor blade
• fresh-carved stamps

I kept the book simple by using only titanium white and a little titan buff paint with indigo blue ink. I worked quickly on several

pages at once, layering the paints and adding a splash of ink here and there to tint the paint blue. Then I scraped and wiped the paint with a piece of mat board, leaving the lines and marks made by the motions (adding only a light layer to coat each page minimizing the amount of texture). For any pages that appeared too textured once they dried, I gently scraped off the texture with a razor blade, leaving a smooth surface for stamping.

Once the pages dried, they were ready for stamping. (In my opinion, the more contrast on each page, the better. Spice up a page that appears dull by adding a wash of ink.) I spread a layer of titanium white paint on a clean palette and stamped into it with a stamp, moving it onto the blue backgrounds. For those pages lighter in color, I reversed the method, stamping with indigo blue ink. Some pages needed one stamp; others I filled to the brim with designs. Once I stamped the pages, I personalized them even more with a white gel pen, adding designs, words, and drawings.

STAMPING EXERCISES

To practice your stamping techniques, here are several exercises:

• Create a handful of stamps made from your own designs.

• Choose an image. Carve the positive space, then the negative space.

• Carve a stamp without any prep work, right on the block, to see what happens.

• Make a personalized stamp for a friend, and then make cards from it.

• Create a little book of stamps (see "My Little Book of Stamps") by painting journal pages in a monochromatic theme, then adding stamped images using paint.

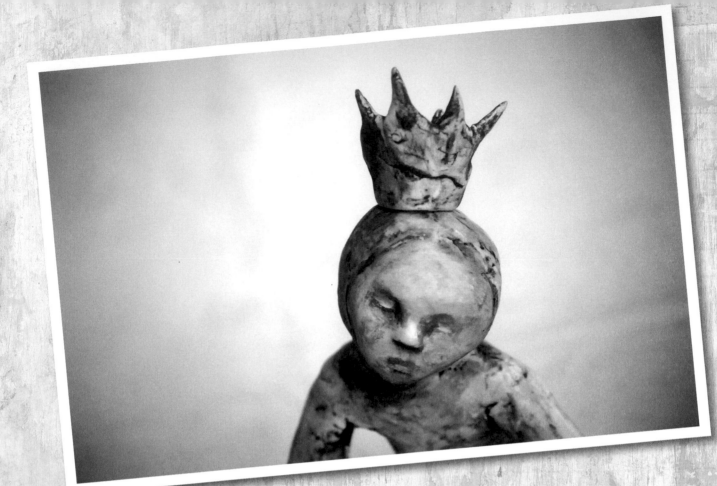

Paper Pottery

When I was twelve years old, I first saw a children's pottery wheel at a store. I wanted it very much. Years later, I actually found myself sitting at one, not child-size, but the real deal. In high school, I learned the basics and got limited time to experiment, but it was enough exposure to know that I wanted to make more pottery. Starting from age twenty-two, I spent many years learning the ins and outs of the pottery studio. I even created my own pottery line and spent summer weekends selling pieces at art shows. That feels like a lifetime ago. My kilns now rest until the time comes to fire them up again. Until then, I rekindle my pottery love with paper clay, a versatile clay made from clay binders and paper pulp that air-dries.

There is something so gratifying about turning a lump of solid clay into an object both useful and beautiful at once, whether it's a bowl, teapot, or sculpture. An intimate relationship stirs between artist and clay that results in enjoyable hours spent giving birth to new creations.

"To produce is to draw forth, to invent is to find, to shape is to discover."

—Martin Buber

In this chapter, discover the pleasure, discipline, and vast imagination that working with clay awakens. Like any art medium, clay is just as stubborn as it is forgiving, depending on its mood and how it is being used. The gift of paper clay is that it allows for more freedom in the studio, liberating you from worries about where and how to fire the finished piece. It is versatile, and you can paint, stain, collage, and transform it in many ways. Add ink or paint to tint the clay. Once the piece has air-dried, sand it, if desired. The one downside of paper clay is that it doesn't produce entirely functional pieces; a paper clay cup or teapot cannot hold liquid. But that doesn't mean it can't be a work of art.

Materials

Here's what you need for paper pottery.

- air-drying paper clay
- wooden modeling tool
- rolling pin
- wooden or metal rib
- needle tool
- small sponge
- smooth work surface
- spray bottle or container with water
- clay or rubber stamps

Handmade Coil Pot

Coil-made pottery was created thousands of years ago. To this day, artists continue to expand on this once-prehistoric method, creating functional and nonfunctional forms as a way of expression. Did you know you can create almost any form you conjure up with just the simplest tools and small amounts of clay? For some, it's a humbling challenge, but with effort and determination, it's possible.

Regardless of what you want to make, the productive technique of using coils allows leeway while building. Have some idea of the hoped-for shape and size before you begin so you know how much clay you need. For one coil, a small handful of clay will do, but for a whole pot, take a softball-size chunk.

Now follow these steps:

1. On a flat, firm surface, roll out coils with palms or fingers, making them each the same diameter. To create a base for the form, either spiral a coil or roll out a small slab of clay with a rolling pin, to which you will add the first coil. It's good habit to score or incise a coil before attaching it to the form; this ensures that the coils bond, limiting the chance they will come apart later.

2. After placing several coils, using your fingers or a wooden tool, begin to adjoin them completely by pushing together the clay joints or seams, smoothing the clay out as you go. Do the same on the inside of the form.

3. Continue placing coils until the piece of art reaches the appropriate height and you feel ready to define your piece's shape. Try to keep the walls of your piece consistent. The bottom coils, or foundation, can naturally be thicker to give the piece stability.

4. To define the shape of your pot, use your fingers or a wooden rib and begin gently working the clay into the

If the clay begins to dry as you work, dab a small amount of water over the surface with a damp sponge or cloth. Too much water can collapse the form or result in coils not proportional to the rest.

desired shape. To belly out the bottom (create a bottom that's wider than the top), push lightly from the inside of the pot. Prevent cracking by using the edge of a metal or wooden rib to smooth the outer surface, even if you plan to later add texture or stamps to the pot's outside. Need a little more guidance? Form the clay around an object—perhaps an upside down plastic bowl or an inflated balloon—that you can later remove.

5. After blending the coils and defining the form, add texture (see the "Ideas to Create Texture" box on page 72) or let the piece dry. Paper clay typically air-dries within twenty-four hours or quicker in an oven set at a low temperature. Check the clay's package for what temperature to use.

6. Once dry, the piece is ready to paint, collage, or design. I prefer a layer of ink to show off the clay's textures. (Sometimes, after I apply the ink, I lightly wipe away the top layer with a wet cloth, giving more contrast to the ink left in the crevasses.)

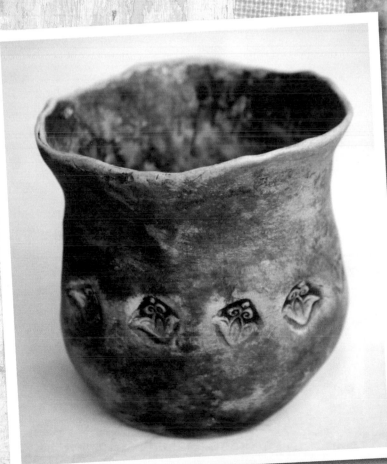

IDEAS TO CREATE TEXTURE

Textures come in all shapes, forms, and sizes—literally—and come from all manner of techniques. Just make sure to test any option on a trial surface before committing it to the entire piece.

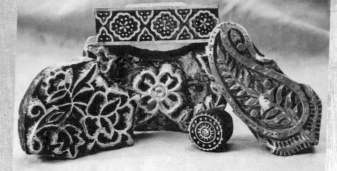

• Nature abounds with textures. Leaves, sticks, flowers, nuts, you name it. Press any of these into clay to create an imprint, then paint the imprint to enhance its details.

• In the previous section of this book, you learned how to make stamps. Why not use one you've created out of clay, foam, or rubber to give your pot texture?

• Draw or carve directly on the pot to add textures. Do this before or after the clay has dried.

• Store-bought stamps, Indian wood block stamps, and stencils are other great options.

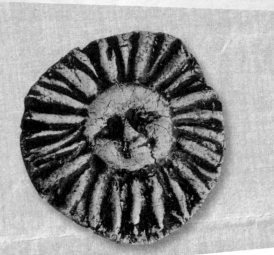

Teapot

To make a paper clay teapot, start by making a coil pot base. Using the needle tool, cut a hole in the side of the pot for the spout and score it. For the spout, spiral a clay coil into a cylinder that narrows at the top, then blend together its seams and score its bottom rim with crossing incisions. Mount the spout rim onto the hole of the pot, blending the clay from the two pieces with a wooden tool.

Now it's time for the handle. On the exact opposite side of the pot, score a spot for the handle's top. To make a handle, roll a thick coil of clay until it narrows at one end, creating a cone. Score its thick end, then attach it to the teapot, adding more clay to sturdy it. Attach the handle's narrow end to the pot and blend the clay where needed. (For another variation, arch the handle across the top of the teapot.) Finally, make a lid by placing coils into a spiral shape wide enough to cover the hole, then blending together the coils. Add a rim on the lid's underside, if desired. Once the teapot dries, paint, collage, or detail it in any way imaginable.

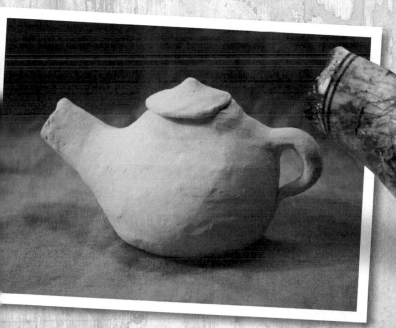

Sculpture

A vast number of materials and techniques can be used to create a sculpture. I provide a very basic method, using newspaper or pattern tissue, masking tape, and paper clay.

Materials

- newsprint or pattern paper
- aluminum foil (optional)
- shaping materials such as cardboard, sticks, wire, polystyrene foam, paper cups, balloons
- masking tape
- ink
- paint
- stamps (optional)

First make an armature (a framework around which to build the sculpture) by crumpling newspaper with or without aluminum foil into a tight ball or any desired shape. Add pieces of cardboard, sticks, wire, polystyrene foam, paper cups, or a balloon to the armature to give it more or random shape. Apply masking tape to the form to sturdy it. Once your armature is the correct shape and feels solid, begin laying thin slabs of clay, one at a time, over the armature. Continue to shape the clay around, extending it where necessary. After covering the entire armature with clay, refine the sculpture's shape. Let the piece air-dry completely before painting or adding accessories.

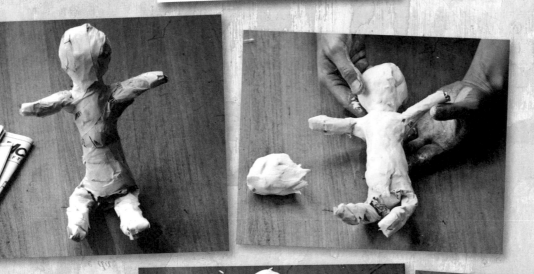

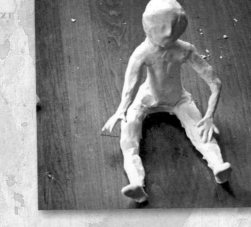

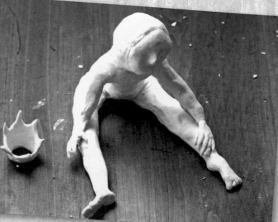

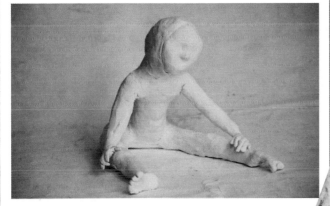

SCULPTURE EXERCISES

Try some of these to practice your sculpting skills:

• Create a set of coil pots, then stamp a design into each one. Paint or add ink to the dried pot.

• Use paper clay to make a handful of buttons or embellishments for your journal or other projects.

• Sculpt a teapot and matching teacup, then decorate the finished work.

• Make an original paper clay sculpture using a newspaper armature. Paint the sculpture once it dries.

• Turn the surface of your coiled pot into your canvas. Paint a portrait, still life, or abstract right onto your sculpture or coiled pot.

"There's always a work in progress, be it in the mind, the soul, the heart, or in your hands."

—Rick Howse

Paper Crafts

Origami

Take a perfectly square piece of paper, add a few spring cherry blossoms or a handful of stamped nighttime stars, make a few folds, and what do you have? A crane, a boat, a frog, a tiny book with pages, a fortune teller, an airplane, a hat, a butterfly, a world of amazement. One simple square can become almost any form imaginable just by making a few—or a few hundred—folds. Some of the more complex forms can take weeks to finish.

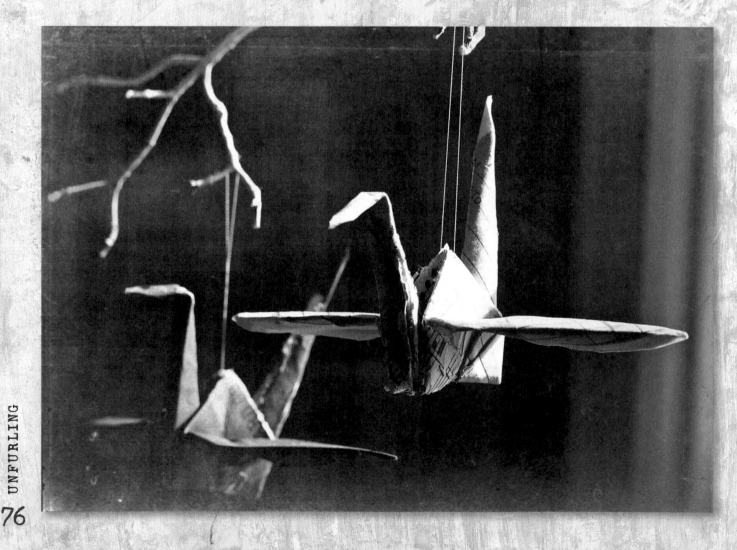

Before I ever folded origami, the process intrigued me. I wanted to magically turn paper into animals, statues, and pockets, but my first few attempts produced nothing more than exhausted pieces of overfolded paper. It felt like I was learning a new language. Then something happened: The paper and my hands started communicating (after much practice), and a crane was born. That solidified my love for and fascination with paper folding.

Origami comes from the Japanese words *ori*, meaning "to fold," and *kami*, meaning "paper." According to lore and history, origami originated in China and came to Japan later, after a Buddhist monk brought paper to the country. Because of paper's high cost at the time, the folded designs were initially used exclusively for religious ceremonies. As paper costs dropped, origami's use expanded, and it became decoration for or accompaniment to valuable gifts and given as a token of good fortune and long life.

Here I show you the basic folding techniques for a crane. I chose this bird for its beauty and because of the promises said to be granted to anyone who folds 1,000 cranes in a lifetime. The crane has become an icon for happiness, good health, and prosperity. One thousand cranes strung in twenty-five strands of forty are often given as gifts at life's monumental moments, such as births or weddings. Today this tradition continues with the Cranes for Peace project, for which folders send in 1,000 cranes each in support of global peace. The goal: to make 1 million cranes annually.

This section of the book is not about traditional origami folding but rather about expanding on the basics. To anyone seriously interested in learning a vast array of origami folding, I suggest heading to the nearest library or bookstore for books concentrating solely on paper-folding. Folding origami can be a beautiful form of meditation, an enjoyable way to reduce stress, as well as a valuable lesson in understanding the importance of patience in the creative process.

Materials

All you really need to fold origami is a thin, perfectly square piece of paper. The paper should be thin, pliable, and willing to hold a crease. Choose from many varieties: handmade, foil-lined, even traditional, store-bought paper. Also select one fitting for what you plan to create. For example, for an intricate design, start with a slightly larger, thin square. If new to folding, try paper with a different color on each side to make it easier to follow the folds. Also, make sure to fold at a flat, clean workspace. Most arts and crafts stores sell traditional origami paper.

Other optional materials include:

- bone folder (to use to make sharp creases)
- stamps
- paint
- inks
- ephemera
- glue stick

Folding a Crane

If you are a beginner folder, I recommend using a larger piece of square paper for this exercise. The more you practice, the smaller the crane you'll likely be able to make.

1. Fold the bottom right corner diagonally up to the top left, then unfold.

2. Fold the bottom left corner diagonally up to the top right, then unfold.

3. Fold the paper in half from the bottom to the top, then unfold.

4. Fold in half from left to right, then unfold. At this point, the paper's lines should look like a plus sign crossed by an X (as in image 4).

5. Flip over the paper and rotate so it appears in front of you like a diamond. Push in the center slightly. Make a valley fold by gently pushing the right and left, then the top and bottom corners together into the center until the paper collapses into a smaller diamond. Make sure the folds are creased well.

6. Turn the folded diamond so the open edges face you. Fold the right side to the middle, then repeat with the left side. Unfold both sides.

7. Flip it over and fold both sides to the middle. Unfold both sides.

8. Push the bottom of the opened side up, then push in the right and left sides along the crease lines you made earlier. Flatten to create a stretched diamond shape (as in image 8). Flip it over and do the same to the other side.

9. Fold the lower right side to the center fold. Fold the lower left side to the center fold.

10. Flip and repeat. There should be two legs that separate nearest to you.

11. Lay the form flat.

12. Push the right "leg" upward between the wings. Push the left "leg" upward between the wings.

13. Fold down each wing. Then fold down the head. Pull it apart slightly so it can stand.

14. And there you have a folded crane.

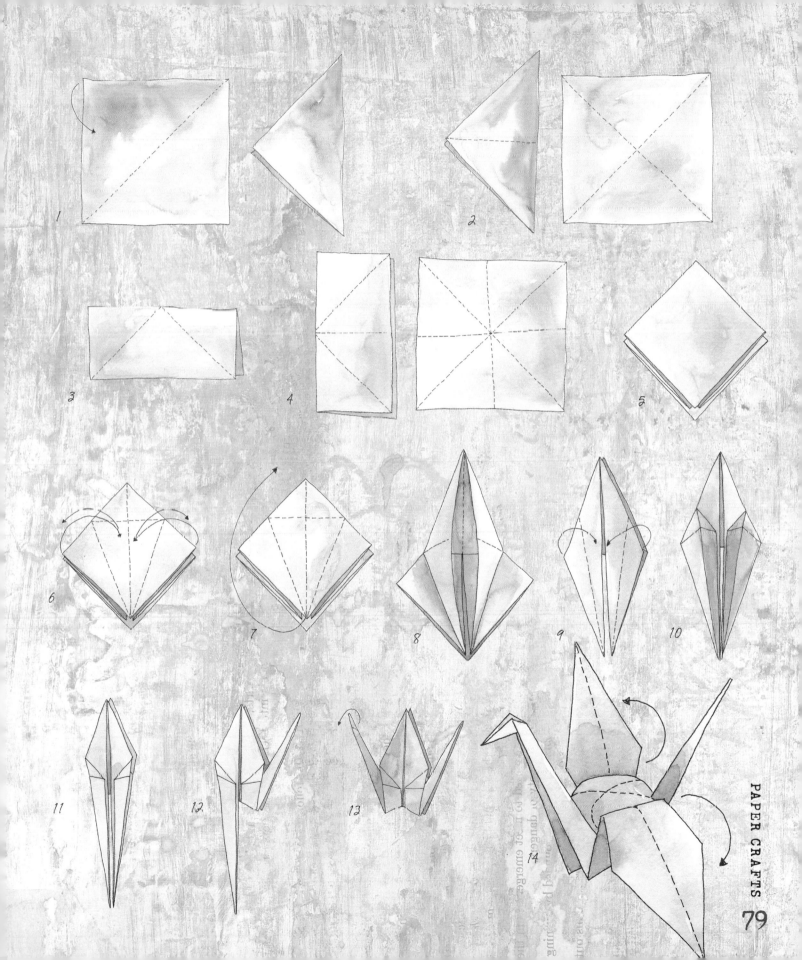

1

2

3

4

5

6

7

8

9

10

11

12

13

14

ORIGAMI EXERCISES

Making folded cranes well takes practice. Here are some exercises to try:

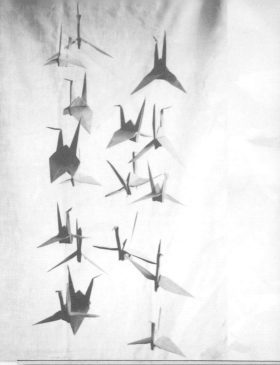

• Fold enough cranes to make a strand. String them together using a needle and thread. Pull the needle up through the center of the crane (the middle back) and then place another on top of that until the strand reaches its intended length.

• Write a message on a square of paper, fold it into a crane, and leave it somewhere for someone to find.

• Cover a thin sheet of durable paper with ephemera, then fold it into a crane.

• Decorate with collage the outside of an already folded shape.

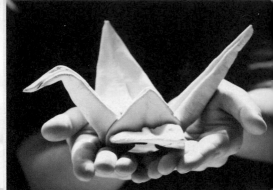

• Roll out a square of thin paper clay, fold it into a crane, let it dry, and paint it.

• Create your own origami paper out of brown paper bags: Stamp on designs and cut into squares.

• Experiment with other paper-folding projects, such as the boxes or boats shown on the opposite page.

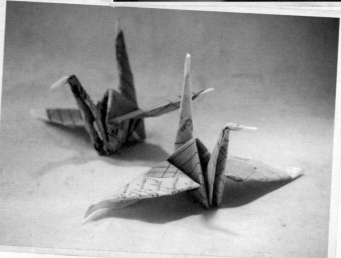

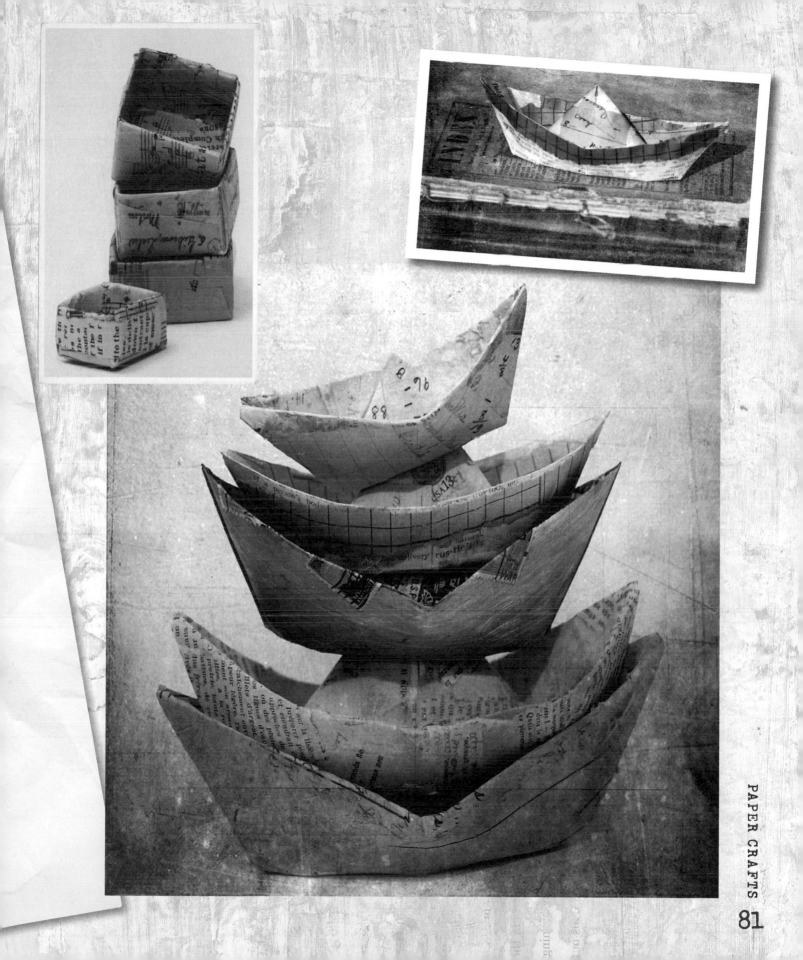

Paper Dolls

Paper dolls are flat figures of all kinds, from people to animals, fairies to fantasy, celebrities to politicians. They often come with separate clothing and ample accessories attachable with paper tabs. Many people collect this popular, inexpensive, accessible toy that's been around for 200 years. Now, they have become an expressive form of art.

But before we go on, a little history: As early as 900 CE, people in Japan used paper dolls for ceremonial purposes. The first paper dolls wore origami kimonos. Then, as part of a purification ritual, they were rubbed against the body to remove any impurities and thrown out to sea or down a river.

The first paper dolls in Europe did not have accompanying clothing or accessories. Sometime during the eighteenth century, paper dolls became entertainment for high-society adults in Europe and tools to ridicule nobility. All over the world, paper dolls of various shapes, styles, and forms started to appear. In the early 1800s, they made their way to the United States, where their popularity continued to grow. Today, they are still popular there.

When my daughter received her first set of paper dolls, I felt secretly smitten with them, sweetly coated with nostalgia. I loved paper dolls as a child, not only the store-bought beauties but my own creations as well. As a mother, I now revel in the chances I get to play (or live vicariously through my children while they do).

If you want to play in your studio, make paper dolls. It's also a great way to involve a child (or adult) in creating something playful, artistic, and rewarding. The paper dolls here are not traditional, but rather mixed-media art.

Materials

• watercolor paper (300 lb hot press)
• pencil
• scissors
• glue
• acrylic paint
• collage images
• embellishments, such as lace, buttons, or beads

Turn to the back of the book for a removable paper doll with two costumes that I designed for you to use and keep.

in order for something else to grow."

—*Ernest J. Gaines*

All Dolled Up

With materials in hand, paper dolls are just a few steps away. On watercolor paper, sketch the doll's shape. This can be a traditional male or female body or a more abstract shape. Next, decide whether to collage the face and body or paint them using acrylics. Once you choose, start with the face and work down the body.

Now it's time for clothing. Create fun undergarments for the undressed figure, then add a cut out dress or outfit. Layer the dress with collage elements and glue them down. Add hands, arms, wings, legs, fashion clothing from magazines, and any other embellishments to give the dress great personality. To make a nice, clean form, cut off pieces hanging over the edges. Tabs on the dress are optional, but something to strongly consider if the doll will actually see play time. Embellish the dress with lace, buttons, beads, and charms. Make several dolls and outfit them for different occasions. Of course, don't forget to accessorize.

If you're worried about drawing a doll freehand, cut out a silhouette shape from a book or magazine, then trace it onto your watercolor paper.

83

journal |ˈjərnəl|

NOUN: a daily record of news and events of a personal nature; a diary

I have heard more than once that journaling is excellent therapy. I very much agree. Many of us start journaling as soon as we can hold a pencil, depicting our thoughts and feelings through images and words. Visual art journaling is a way for an artist (or anyone, really) to keep a diary, a sanctuary for the heart and head, a place to safely unveil emotions, thoughts, worries, and dreams. A journal provides a place to store yourself, to revisit and reflect, one you can easily make new with the swipe of a brush. It can be a cookbook filled with favorite recipes and images of delicious meals. Or maybe it's a scrapbook overflowing with a lifetime of photos. Maybe it is just a place to keep notes, write lists, and store unforgettables. Whatever it means to you, it is valuable.

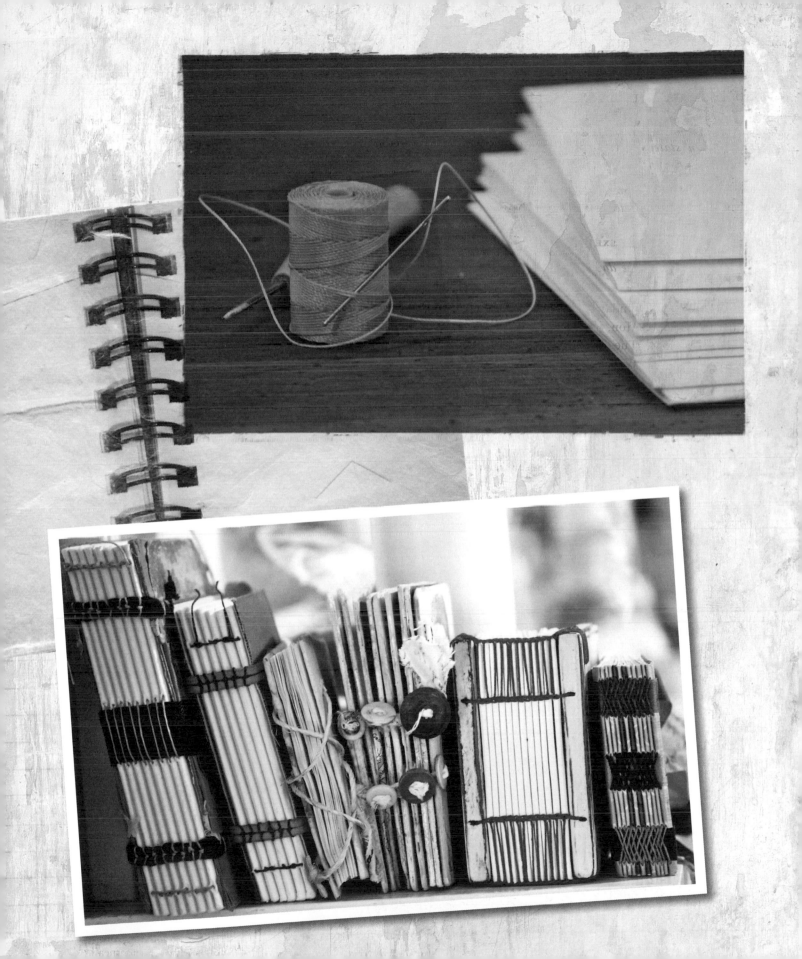

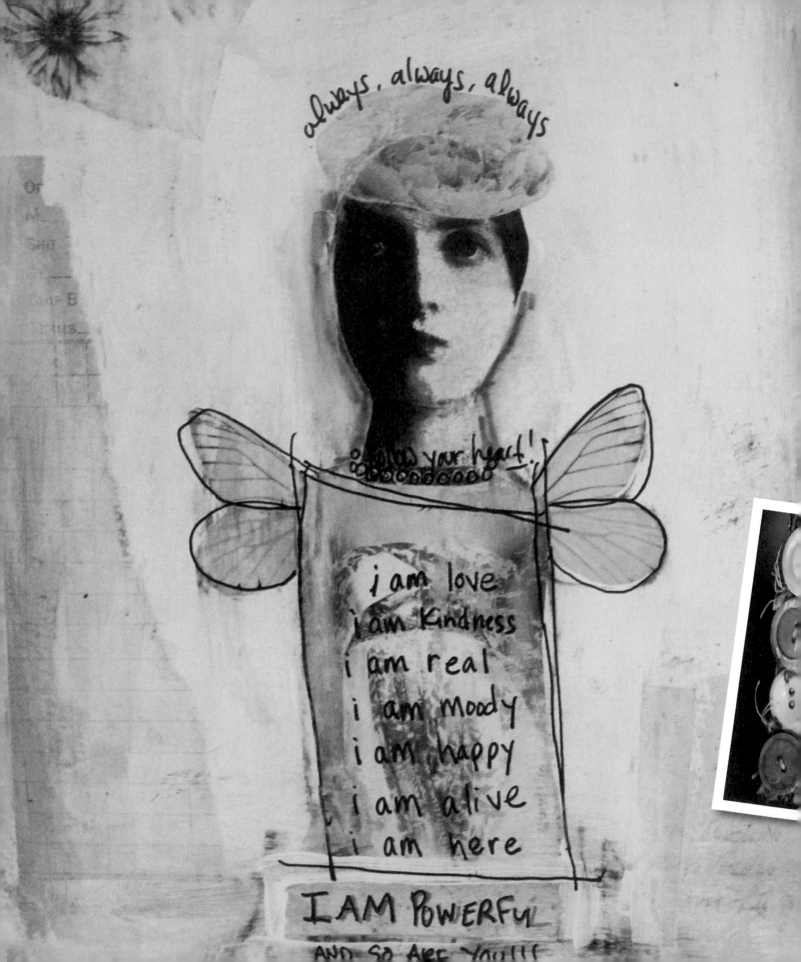

"Visual journaling allows us to access our inner language of imagery and express it both verbally and visually, while exploring the connection between image and word."

—Michael Bell

Journal Making

Art journaling beautifully marries the written word and visual imagery. It gives birth to a soulful reflection of your feelings in a particular moment. There are many ways to journal; the best for you is your way. Remember, your journal does not have to be good or beautiful or perfect. It just has to be yours.

Materials

Journaling can include, simply, a favorite journal with good paper in which you write with pencil or pen. But here are some other options to get creative:

- pencils
- markers
- crayons
- gel medium
- acrylic paint
- photos
- photo corners
- collage images, ephemera, receipts, magazine pages
- embellishments, such as buttons, fabric tape, beads, lace, fabric, and dried flowers
- colorful tape with fun designs
- wax paper to prevent pages from sticking together

BOOKBINDING TERMS

Sheet: One piece of paper, unfolded.

Folio: One piece of paper folded in half.

Signature: Several folios nested together.

Bone folder: A dull tool used to make a sharp crease.

Awl: A sharp tool used to punch holes in signatures.

Sewing stations: The holes in your signatures, where you sew together your pages.

Kettle stitch: A chain stitch that links one signature to the next.

Creating a Journal

Constructing your own journal is a rewarding feat and makes any journal feel more personal. Journal making predates even the invention of paper, in the form of scribing words and messages on clay tablets. The first handmade journals were leaves inscribed with a metal stylus, left to dry, and then rubbed with ink to pull out the inscription. Later, thin pieces of cut wood became journals. The Egyptians used parchment made from sheepskin, folded in half and sewn together, allowing both sides of the page to be used. Eventually, they invented the first paper by beating the flower stem of the papyrus plant into strips, then pressing together the strips to create a sheet. Paper materials moved from the papyrus plant to wood pulp to a vast variety of material today, from cotton and banana peels to hemp and flowers.

Assembling sheets of paper results in a journal or book, but there are many ways to bind together pages. Tie together a stack of folded pages, called a signature, with one piece of thread to create a simple, constructed journal. Or spend hours sewing together signatures using elaborate stitching to create an impressive book. As with most everything in art, a number of techniques and options work, but you must find one that works for you.

I love putting together my own journals for the great satisfaction that I derive from it. This book provides the basics on how to do it, but to truly master bookbinding techniques, use Keith A. Smith's *Non-Adhesive Binding Books Without Paste or Glue* or one of his other professional bookbinding guides.

When I bind a journal, most often I employ the coptic binding technique, a nonadhesive method in which a kettle stitch sews together pages. This method leaves an exposed spine on the finished book, which fabric or paper can cover, if desired. My paper of choice is watercolor paper, which holds up well to many mediums. I select heavier, 300 lb paper (see the "Paper" section of the Drawing chapter on page 16 for more about paper weights) to create journals made to hold many mediums. For journals just meant for writing or glued photos, I use 140 lb watercolor paper. In both cases, I rarely add hardboard front and back covers. This is just my preference.

Bound Together

Here are the materials you need to make a soft cover journal using a kettle stitch:

• high-quality paper all cut to the same size (paper 10" x 5" [25 x 12 cm] makes a 5" x 5" [12 x 12 cm] book)
• bone folder
• pencil
• ruler
• awl
• waxed thread, 3 feet (1 m) or longer
• bookbinding needle

Now, follow these instructions:

1. Prepare your pages for binding by folding each in half to create folios. Use a bone folder along the spine to create a sharp fold.

2. Create signatures by tucking three or more folios inside one another. Make as many signatures as you like. However, as a good rule of thumb, combine three folios to make one signature, and five or more signatures to make one thirty-page book.

3. Mark the spines of each signature with a faint pencil mark where you plan to bore the sewing station holes. Use a ruler or another guide to space the holes evenly. I typically start anywhere from ½ inch to 1 inch (1 to 2.5 cm) from the top of the signature spine, then mark every ½ inch (1 cm). Where you mark is, of course, up to you.

If you don't wish to mark your pages with pencil (as in step 3), make a punching guide using an extra folded folio that's the same size as the others. Punch holes in the guide where holes should appear on your signatures. Place the punching guide inside the signature to position it correctly and flush the top and bottom edges with the top and bottom of the signatures. Stab through the guide holes, all the way through the signatures. Once you ready all the sewing stations, begin sewing them together.

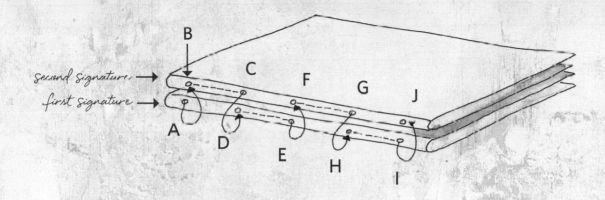

second signature →
first signature →

B C F G J
A D E H I

4. Stab the awl on each mark all the way through the signature.

5. Line up your first signature flush with the edge of a table, with the holes facing you. Thread your needle with waxed thread about 2 feet (60 cm) long. From the inside, push the needle out through the top hole, pulling it to the outside of the signature (A). Leave about 3 inches (8 cm) of thread on the inside of the first signature.

6. Place the second signature on top of the first and insert the threaded needle into the second signature's first hole (B), from the outside. Pull it through, then insert the needle into the second hole of the second signature, from the inside heading out (C).

7. Next, pull it through the second hole of the first signature (D). Before pulling it back out, secure the thread by knotting it with the loose thread from the first signature. Then insert the needle into the third hole of the first signature (E). Pull it through, then insert the needle into the third hole of the second signature (F).

8. Continue working down the book's spine, moving into and out of the two signatures, until reaching the end of the sewing stations (G–J).

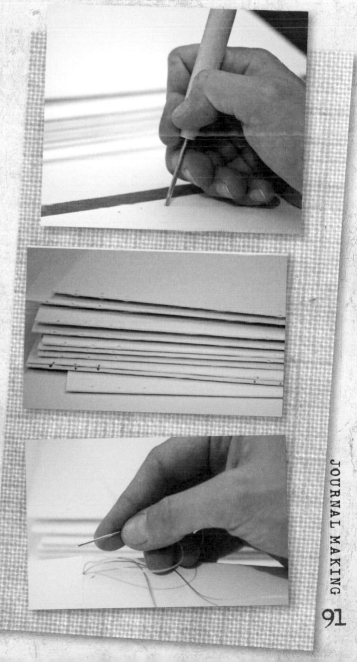

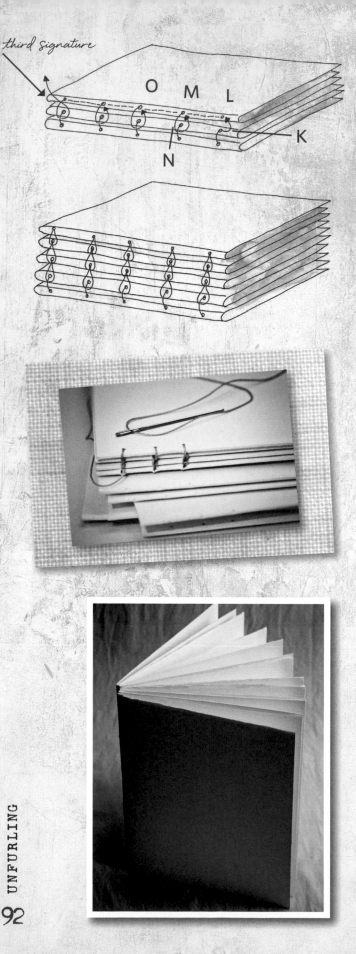

third signature

O M L

N

K

9. On the inside of the signature, wrap the sewing thread around the inside thread of the previous stitch to secure it. Come back out the last hole so the thread is on the outside at the bottom of the book's spine (**K**).

10. Place the third signature on top of the second signature. Thread the needle through the bottom hole of the third signature (**L**) so it ends up inside the third signature. From the inside, go up to the next hole on the third signature and pull it out (**M**). Take the existing thread and instead of going into the second signature, slide the threaded needle under the thread between the first and second, looping the thread around and back into the third signature. You've just created a kettle stitch (**N**).

11. Take the needle through into the third signature's next hole up and loop it to create a kettle stitch, as you did for the previous step (**O**).

12. Continue this method until you reach the top of the book's spine. Repeat the same steps with all signatures.

13. Once you reach the final hole in the last signature, double-knot the thread inside the cover and trim the thread to the length desired. Knot and trim the 3-inch (8-cm) piece of thread you left inside the first signature.

Once you finish your journal, dive right in and fill it to the brim with juicy art goodness!

JOURNAL-MAKING EXERCISES

• Construct a soft cover journal using watercolor paper.

• Create another using all recycled materials, such as cereal boxes, newspaper, or mail.

Art OPEN

Make your Mark

For me, the hardest part about journaling is making the first mark in a brand new, beautiful, untouched, splotch-free journal. Because of this, for a long time I collected blank journals. I must admit I still have a few precious ones I couldn't touch. I feel reservation, fear of frustration, and chagrin in making that first mark. Once I do it though, I dive in headfirst. The first mark acts as catalyst, bringing more life to the journal, not creating an impulse to stop, but rather the impetus to move forward.

The first "mark" could be a photo, a paint streak, a drawing, or a single word. Usually, a word can unravel my thoughts, make me want to pull out my typewriter or paints and dress it up. Pairing a photo with the word often narrates an untold story, opening up many possibilities. Very rarely can I stop here, compelled by what might unfold by adding this or that—layers of paint, crayons, collage, the whole kitchen (even the sink)—to the once singular word.

What I find most valuable about journaling is the freedom to be yourself, without worrying whether what you create is pretty, will sell, or makes any sense. None of these matters. No mask or censors needed here. It is just for you. (As a mother, a wife, and a full-time artist, I rarely find myself making such "just for me" statements, so it is easy to understand the quintessential nature of this kind of freedom.)

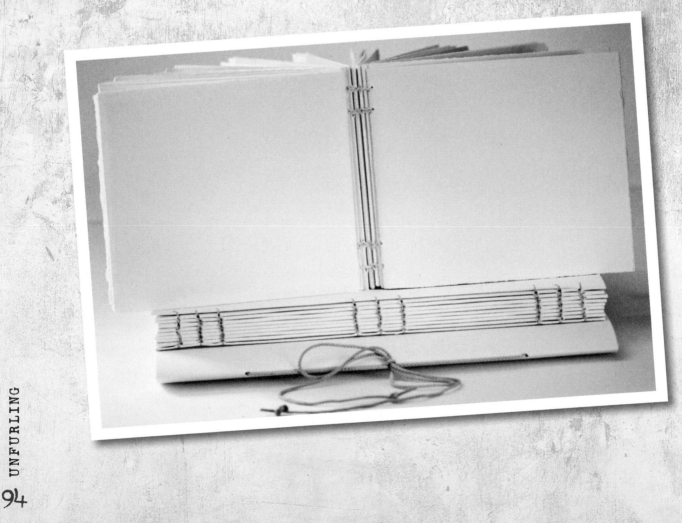

NOT KnOWing When
THe dawn Will cOME
Open every DOOr

Lucky you.
Get out your party clothes.

emily dickinson

AFTERNOON HOUR

One of my favorite times of the day during the school year occurs just after my children come home from school, when we have our afternoon hour (something we made a regular gathering in 2008). It's an hour dedicated to reading or working in our journals, without music, computers, television, or phone calls. Both of my children have a few journals in which they enjoy working.

We find the sunniest spot in the house, pile up a few pillows, make tea, and begin drawing, writing, and sharing the precious time together. They have come to love it; even their friends who have experienced it enjoy it. It makes my heart ache—in the best of ways—to thumb through their journals, seeing how their work has evolved over time. Our afternoon hour has proven just how important it is to journal—for me and together with them— giving us the opportunity to learn and expand together.

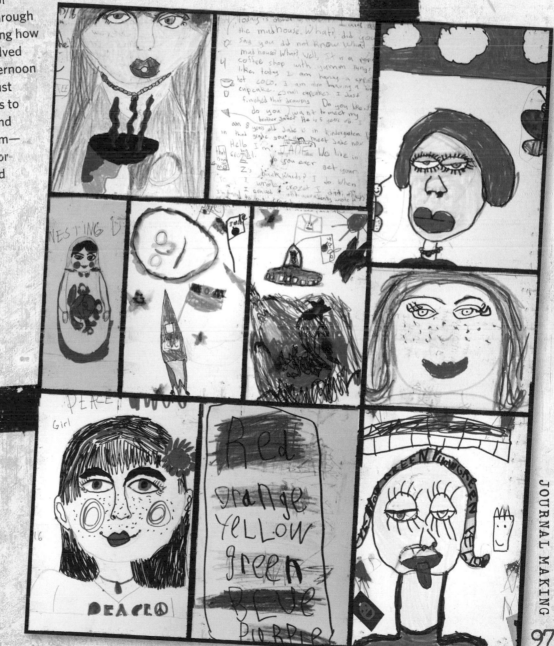

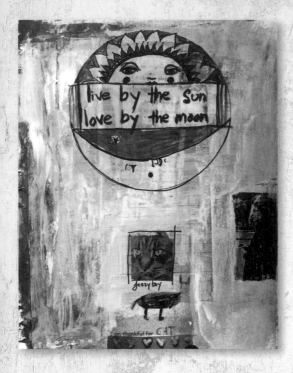

Mix It Up

Many artists out there stick to only one medium in their journals: watercolors, pen, paint, pencil, crayon, or collage. I cannot pick just one, so I choose them all. Working in several mediums allows for more spontaneity. Add a layer of paint for a background, collage over it, paint over that, glue a photo on top, scribble down some thoughts. Keep building layers until the page looks just right.

Expectations of the finished product should—and do—change throughout the journaling process. The pages unfold gracefully, without force. The process itself offers almost as much reward as finishing a page or a whole journal. Spending quality time journaling recharges and inspires the soul.

To broaden the appeal, share journaling with a close friend or companion. Swap journals back and forth, each working on the same pages at different times. Collaboration like this is not only fun, but it's a wonderful way to get to know someone better and share yourself, too. Expect some level of vulnerability from this kind of sharing. It's only natural. But from my experience, those feelings dissipate pretty quickly.

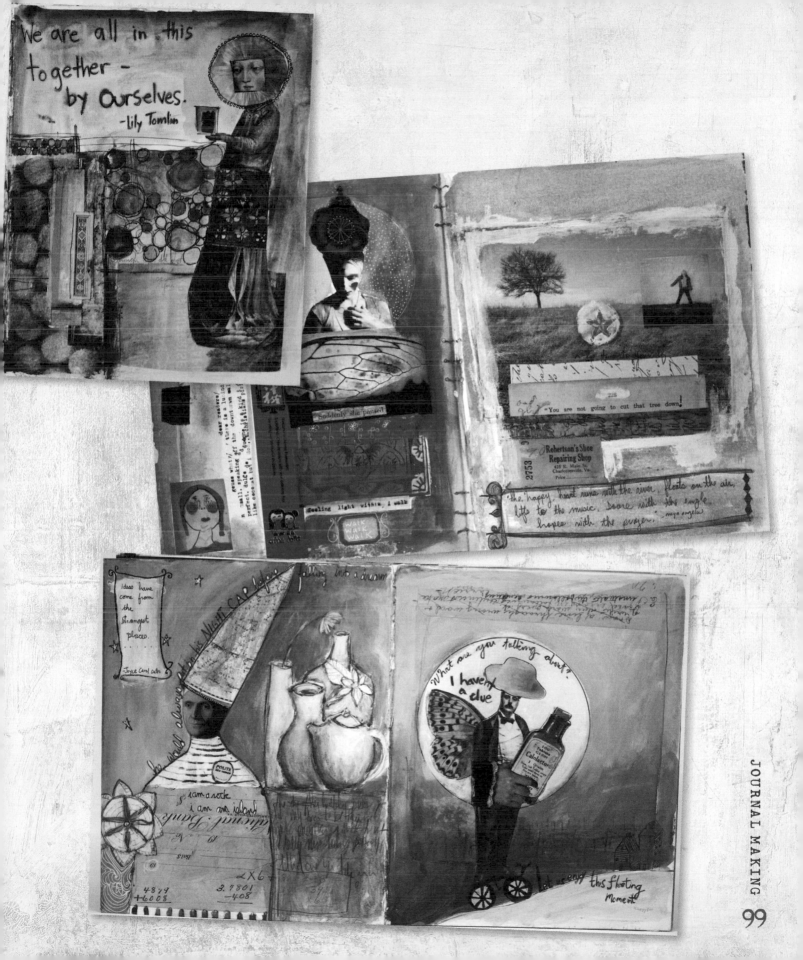

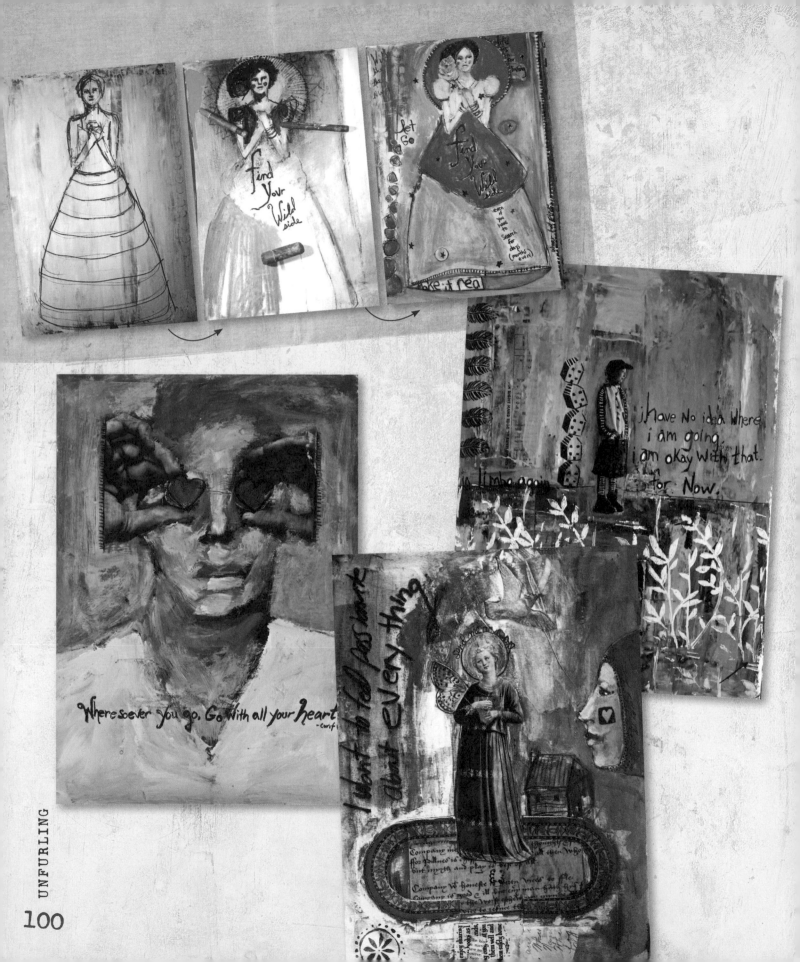

Find Your Wild Side

Let Go

Find Your Wild Side

even if you have to search for days (months even)

make it real

i have No idea where i am going. i am okay With that. for Now.

in limbo again

Wheresoever you go, Go with all your heart. —confu...

i want to tell passionate about every thing

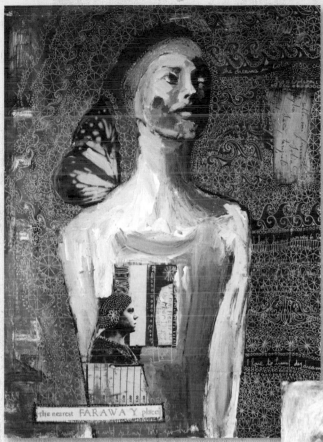

JOURNALING EXERCISES

Try a few of these exercises to get inspired:

• Find inspiration in a favorite artist by creating a journal spread in his or her style.

• Design a menu or brochure (for anything anywhere).

• Paint a picture of any object in the room.

• Create a whole journal using one color (a color theme) or every color in the rainbow.

• Draw a grid on a journal page, then paint or draw the same image in each box seeing how it changes. Title each image.

• Ask a close friend to collaborate, make or buy two journals, and let the fun begin.

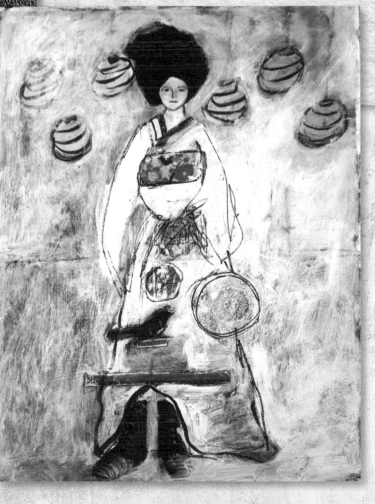

Always we hope someone else has the answer.
Some other place will be better.
Some other time it will all turn out well. This is it.
No one else has the answer.
No other place will be better,
and it has already turned out.
At the center of your being you have the answer;
You know who you are and you know what you want.

Photography

Photography is much like keeping a journal, even if the photographs never make it into a journal, photo album, or scrapbook. Hundreds of photos, most of which I'll likely never print, sit on my computer's hard drive. They showcase walks in the woods, photos from a workshop, or family. Going back into my photo archives, I reminisce about each photo's frozen moment. I love that about photography. It has a great ability to turn back time, to evoke memories and emotions.

Adding photos to a journal is a lot like adding illustrations to a book; it enhances the rest of the material. I love including my own photos in journal pages because it further personalizes them and it conjures two different moments in time: when the photo was taken and when I placed it in the journal. Sometimes I pick family photos or glimpses of nature. Sometimes it's places I have visited or an expressive self-portrait. Photo-ready moments are everywhere, and with the invention of the digital camera, they're easier than ever to capture. There are even mini-printers you can tuck into your bag and print from on the go.

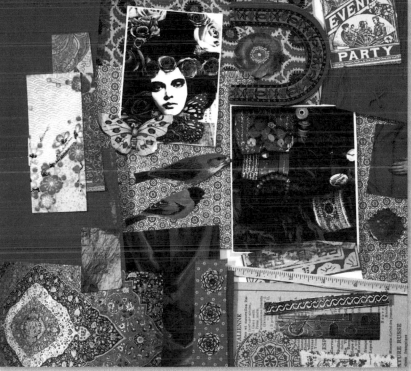

A NOTE ABOUT PHOTO EDITING

Ever since Adobe Photoshop found its way onto my computer, I absolutely love the photo-editing and -altering processes. I can get so focused and involved that it can take an hour to edit just one image. I change not only the saturation levels of my photos, but also the texture, opacity, and sometimes, the era (time period). I take those altered photos, print them out, and alter them even more on my journal pages.

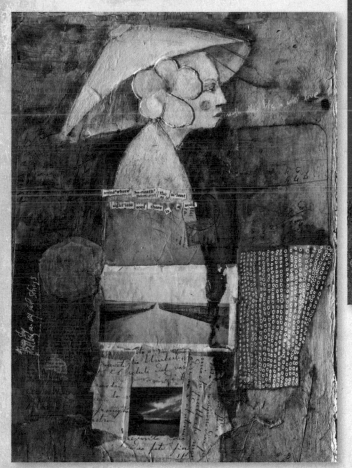

"Nothing is rich but the inexhaustible wealth of nature. She shows us only surfaces, but she is a million fathoms deep."

—Ralph Waldo Emerson

Nature

After my children, nature is my favorite subject to photograph. Something about being outside, in the moment, then capturing that moment with a click evokes strong emotions. And like children, nature constantly changes. Blink and the trees have a full coat of leaves. Blink again and the cicadas are gone, winter is moving in. These changes make me reach for my camera; I know all too well that I cannot stop time. But I can freeze-frame it

Nature's photographic offerings are boundless—from a handful of sea-shells to freshly fallen petals on green grass to a newly knit gossamer web—

making it easy to fill your camera's lens (and memory card or film) with an array of beauty borrowed from nature. Adding these photos to my journal grounds me, deepens my connection with the natural world, and I love watching it work its way into my art.

Beauty isn't nature's only gift. Nature is the purest form of reinvigoration. When I feel frustrated with my work or need refueling, if I go outside and soak up nature, I automatically feel better.

"Nature has been mastering itself for some time now, and it is an honor to be able to capture its beauty."

—Justin Beckett

"I paint self-portraits because I am so often alone, because I am the person I know best."

—Frida Kahlo

Self-Portrait

Why do so many artists, photographers, and writers create self-portraits? People experiment with and create this type of art for many different reasons, but many feel an underlying desire or pull to use a self-image to push self-expression further.

The idea of taking, creating, or using a self-portrait can initially seem intimidating or egotistical. But like all forms of self-expression, this becomes more rewarding and fulfilling the greater your comfort level. Self-portraits and journaling go hand in hand. Both are personal in nature. Self-portraits do not have to show your face or your body. A pair of your shoes sitting in the evening sunlight (or anything you love, for that matter) may feel to you like a self-portrait.

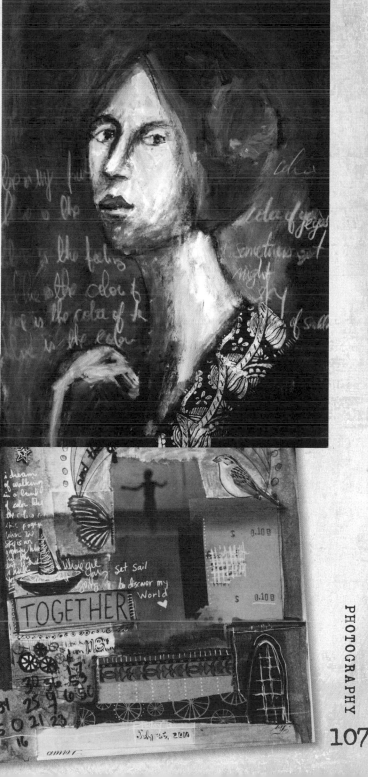

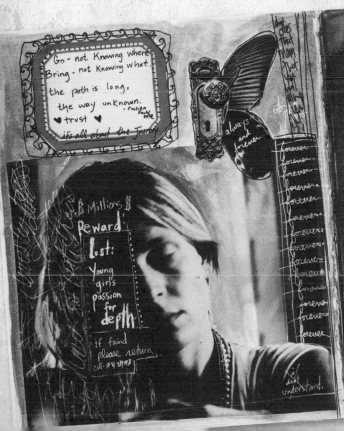

BOOST FROM A BLOG

When the online world first piqued my interest, I found a blog about self-portraits that encouraged readers to take photos of themselves each week within a certain theme, then submit their best to the site. At first I found it challenging to take and share a photo of myself, but soon I immersed myself in the experience.

I looked forward to the showcased photos on the blog's front page, as well as seeing how others interpreted that week's theme. Taking self-portraits became an inspiring pastime. Each theme encouraged something inside of me to crack open a little more. Digesting the theme, I'd brainstorm, often ending somewhere near to but completely different from my initial idea.

Not until a few years ago, after the blog had retired, did I do something more with the self-portraits I had collected. I began printing them out and adding them to my journal pages, altering them by painting and drawing on them or building collages around them. Perhaps one day, these self-portraits, as well as all the other photos, journal pages, and artwork I have gathered, will be for my children (and their children) an entertaining and enlightening window into my life.

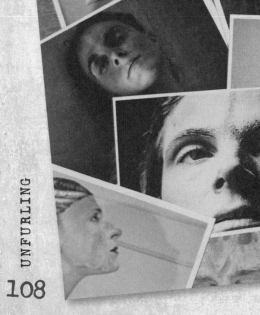

SELF-PORTRAIT EXERCISES

There are many ways to take a self-portrait. Set up a tripod and use a timer or remote. Take it in the mirror or a pool of water, as a reflection. A self-portrait can even be a photo of your feet or hands. Here are some ideas to practice:

• Create a self-portrait journal using only photos of yourself.

• Write down a handful of themes or use the ones listed on page 111, and take a self-portrait for each theme. Print them out and add them to your journal pages.

• Take a picture of yourself outside—in the woods, on the street, or in your backyard. Take a mirror or props to experiment with.

• Paint yourself using artist crayons (dipped in water first.)

• Bring out your alter-ego in full bloom. Add photos to your journal.

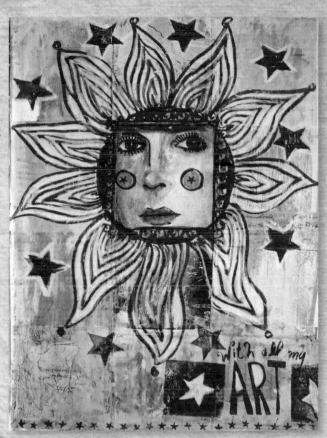

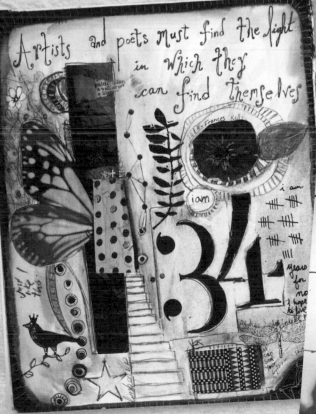

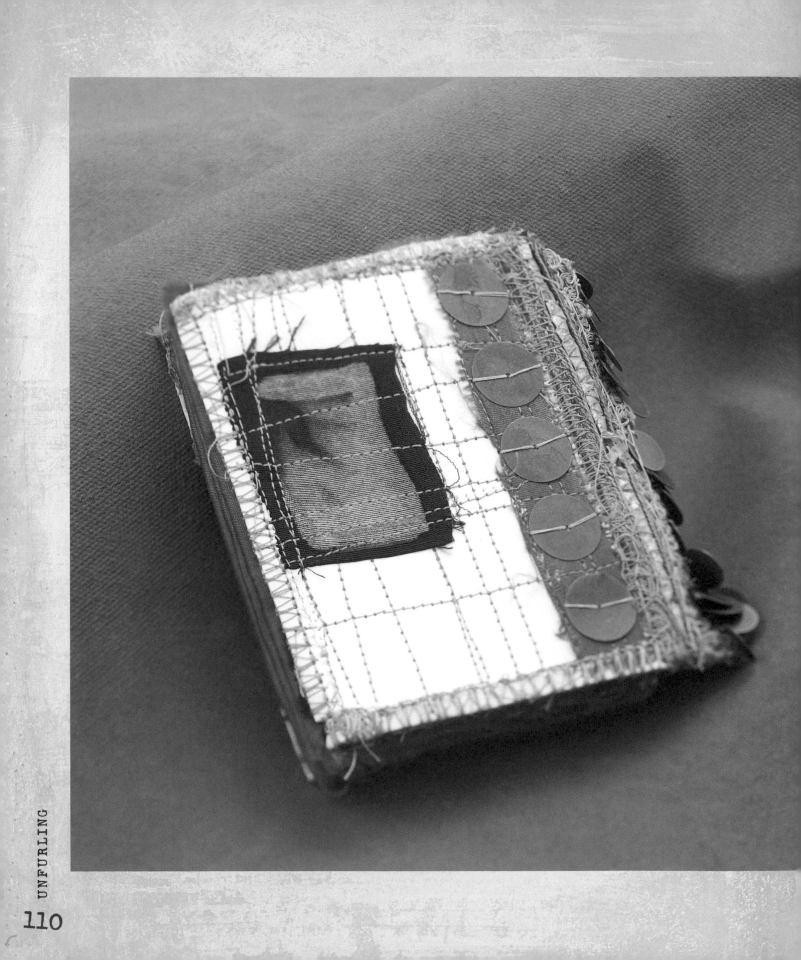

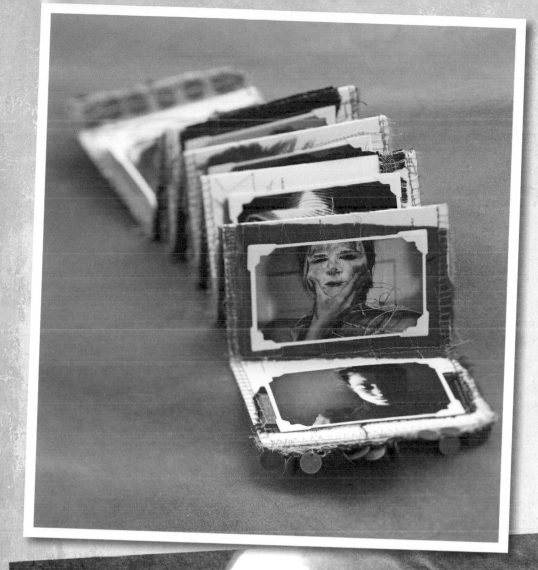

Try these self-portrait theme ideas:

- Shadows
- Bloom
- Light
- Mischief
- Childhood
- Stillness
- Shocking
- Unspoken
- Delicate
- Kitchen
- Found
- Quiet
- Leaves
- Far away
- Water
- Overwhelmed
- Bliss
- Glamour
- Disguise

Poetry

What is poetry? The dictionary describes poetry as something that arouses strong emotions because of its beauty. With that definition, wouldn't a morning autumn landscape exploding with color be a poem? What about a newborn child in the arms of her mother? Is that, too, a poem? I suppose they could be.

I love to think of poetry in this manner. How can you go wrong in writing a poem with this as the definition? I once heard a poet speak about where he got his poems; he said he reached up into the air, waited, pulled them out, and wrote them down. I love the idea of a poem being deeply moving, but I don't think it always has to be. A poem can be playful, angry, or even a little flat yet still worthy of writing down, keeping, and sharing. If beauty is in the eye of the beholder, poetry must be as well. Writing poetry daily—just like making art—is an amazing path to self-discovery and self-expression.

Poetry in a journal is a beautiful way to express the moment's feeling without having to unveil your innermost thoughts. Poetry can be purposefully vague or utterly revealing, depending on your mood. It is truly a satisfying feeling to read a poem that exemplifies my feelings in the moment. I connect to the poet, the idea behind the poem, even the mood that sparked the connection.

If you don't have confidence to write your own poetry, borrow work from one of the many amazing poets out there. Print out a poem and glue it in your journal, then work around the poem: Add color, collage, or your own personal touch. Use a script brush and scroll the poem across already painted pages. Write down the poem in your own handwriting. If you feel up to it, add your own poetry to personalize the pages even more.

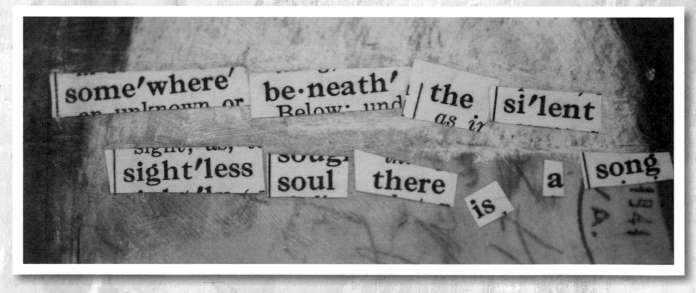

"A musician must make music, an artist must paint, a poet must write, if he is to be ultimately at peace with himself."

—Abraham Maslow

The Art of Disappearing

When they say Don't I know you?
say no.

When they invite you to the party
remember what parties are like
before answering.
Someone telling you in a loud voice
they once wrote a poem.
Greasy sausage balls on a paper plate.
Then reply.

If they say we should get together.
say why?

It's not that you don't love them any more.
You're trying to remember something
too important to forget.
Trees. The monastery bell at twilight.
Tell them you have a new project.
It will never be finished.

When someone recognizes you in a grocery store
nod briefly and become a cabbage.
When someone you haven't seen in ten years
appears at the door,
don't start singing him all your new songs.
You will never catch up.

Walk around feeling like a leaf.
Know you could tumble any second.
Then decide what to do with your time.

Use Your (Poetry) Words

If the idea of writing poetry is intimidating, have no fear. With practice, you can write a poem that is journal-worthy. First try this: Use this collection of random words (feel free to add words of your own) to create a poem of any kind. Do it again and again to see differences and similarities in each poem. They can be long, short, or somewhere in between. Add the poems to your journal pages.

drifting clink apple quilt journey shall truth look petal fragile deeper rain heard cringe tell forward laughter cannot kindly unwanted wonder fire breakfast forsaken today invisible found long sky hand love nobody wings joined yesterday myself left insipid old real who listen walk loss hidden cover longing sideways cured scalding river went toward mother bliss darkness bloom fell tomorrow less hill trouble have now this since gift twisted tell here snow internal without while drank door small billow quiver branch bird raw house again eat blue sister body pod lure heart apathy fly child solitude unbeknownst open however tenderly lover music cold beauty treasure sick seed sit nourish anchor back jealous flour pond away soul trace in wish why where then but than us you him her she it he is now the I and a you

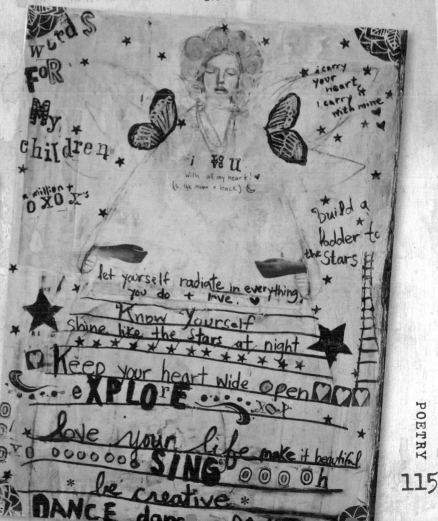

Example:
I twisted forward in the darkness
heard the invisible bird of my soul
fly toward the back door
where it went I cannot tell

When stuck on what to write in your journal, choose a prompt (from the list below or any others you have in mind) to guide you into writing.

- If I had 5 million dollars I would . . .

- I dream of . . .

- When I was twelve (or twenty-four) . . .

- When I am 95 (or 110) . . .

- There is a place I long to be . . .

- I am . . . (500 words in random order that describe me)

- There was a time when . . .

- I love you because . . .

- If you only knew . . .

- I am not only a (fill in the blank), but I am also a (fill in the blank)

- Here is what surrounds me at this moment . . .

For another enjoyable and expressive way to write poetry, cut out a handful of words from a book, perhaps even a whole sentence here and there, and reassemble the words. Remember, this is your journal. Unless you plan to submit these poems to get published, don't worry about whether they are well written, make sense, or are even legible.

Like any work of art, some poems take longer to create than others. Some are more abstract than others. Some evolve over time. I like to think of writing poetry as having an intimate conversation with myself that I may wish to read later in life. Perhaps it's a simple story about

finding the perfect orange at the grocery store, the dew left on my heart from my morning walk, or the way I feel about the changes around me. Reflect on how you feel in the moment, write it out entirely, then refine it into a poem. Don't be afraid to use your journal as a sounding board or scratch out words when necessary. Your marks add to your journal's design.

Still need more ideas? Add quotes, haikus, song lyrics, or excerpts from a novel that resonate with you.

POETRY EXERCISES

If you're still not sure whether you're a poet, try these exercises:

• Write a handful of poems using the list of words on page 115.

• Create a poem about yourself and then pair it with a self-portrait in your journal.

• Make a stack of postcards with painted backgrounds, write your poems on the front, and send them to your friends or leave them in public for others to find.

Resources

Books

The Book of Qualities, by J. Ruth Gendler
Etcetera: Creating Beautiful Interiors with the Things You Love,
 by Sibella Court
Fuel: Poems by Naomi Shihab Nye, by Naomi Shihab Nye
New and Selected Poems: Volume One, by Mary Oliver
Non-Adhesive Binding Books without Paste or Glue,
 by Keith A. Smith

Studio Supplies

**Blockheads Unmounted Rubber Stamps and Rubber
 Stamping Supplies**, www.blockheadstamps.com
Dick Blick Art Materials, www.dickblick.com
Ebay, www.ebay.com
Etsy, www.etsy.com
Green Pepper Press, www.greenpepperpress.com
JetPens Japanese Pens and Stationary, www.jetpens.com
Painter's Keys, www.painterskeys.com
Stencil Girl Products, www.stencilgirlproducts.blogspot.com

Artists

Dan Eldon, www.daneldon.org
Sabrina Ward Harrison, www.sabrinawardharrison.com
Teesha Moore, www.teeshamoore.com

Artist Workshop and Retreats

Adventures in Italy, www.adventuresinitaly.net
Art & Soul, www.artandsoulretreat.com
Artfest, www.teeshamoore.com
Valley Ridge Studio, www.valleyridgeartstudio.com

Acknowledgments

I would like to thank everyone out there who helped me get to where I am today. My parents, my husband, my family, my friends, my many patient art and nonart teachers throughout my life, to everyone at Quarry, and finally, to everyone who, in some way or other, encouraged me to do what I love. Thank you.

About the Author

Misty Mawn is a mixed-media artist, avocational photographer, international workshop instructor, and passionate mother. She has been an artist her entire life and feels compelled to create any chance she gets. When she is not busy singing out loud in her studio, she is most likely found amusing her two children, inventing in the kitchen, or looking for treasures. She has been published in a variety of magazines, including *Somerset Studio*, *Cloth Paper Scissors*, and *Art Doll Quarterly*, and has contributed to several books, including *The Artistic Mother*, *Creative Wildfire: An Introduction to Art Journaling*, *Collage Lab*, and *Mixed Emulsions: Altered Art Techniques for Photographic Imagery*. This is the first book she has authored.

Templates

Stamps

See page 63 for instructions on transferring these designs to a stamp.

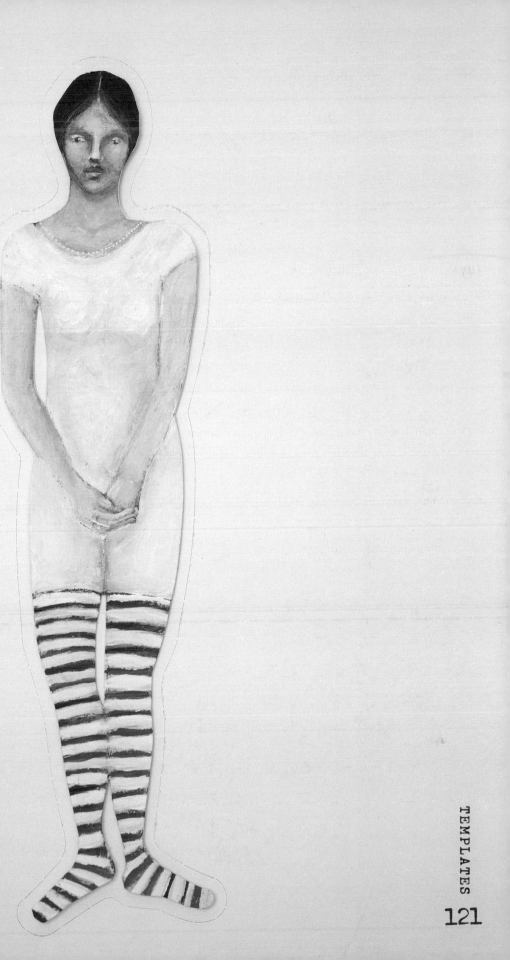

Paper Dolls

Carefully remove the paper doll and doll costume pages one sheet at a time by folding and then tearing along the perforation at the inside of the page. Then, carefully tear or use scissors to cut around each item following the perforation marks.

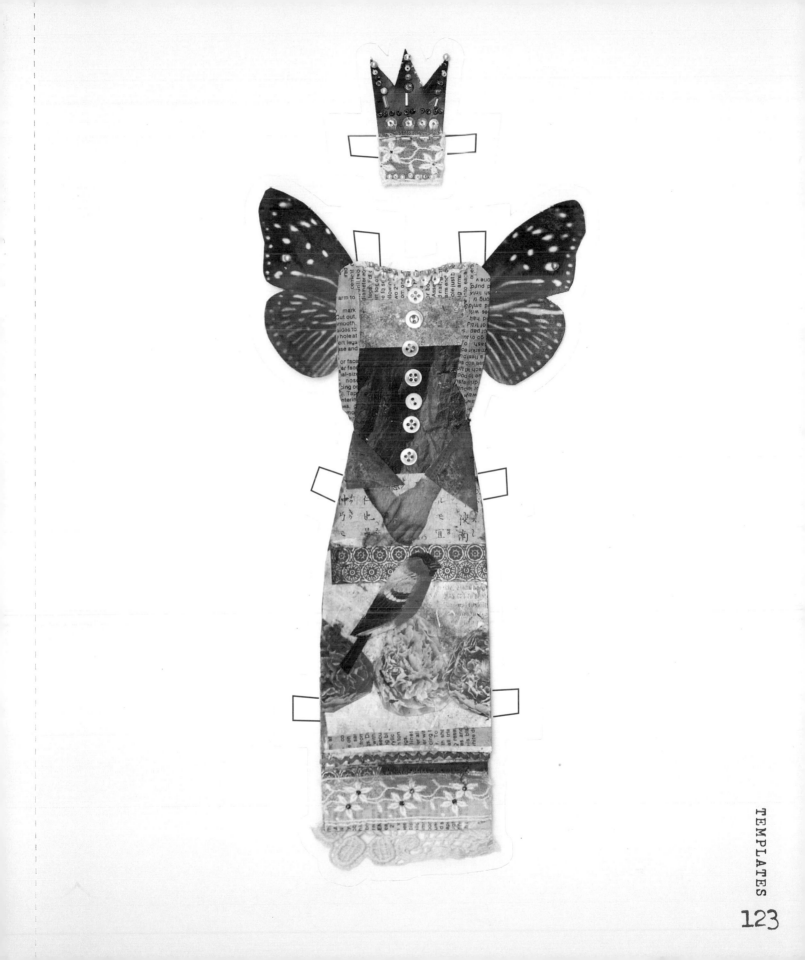

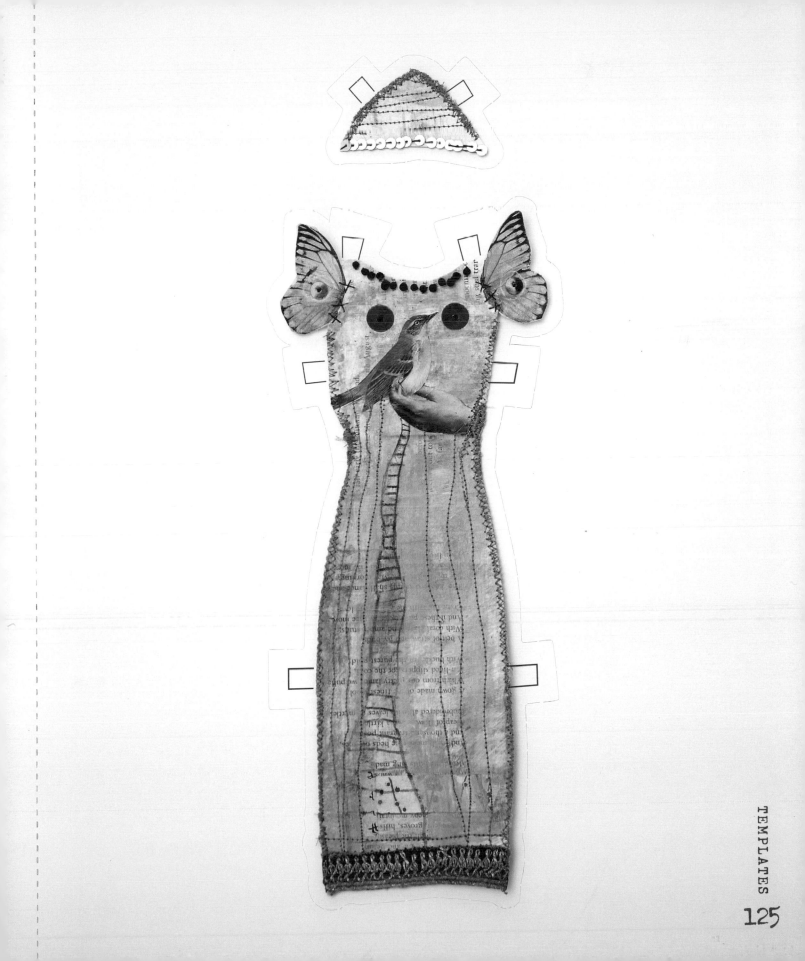